THE RODALE BOOK OF
Garden
Photography

DATE DUE

TR
724
.F57

THE RODALE BOOK OF
Garden
Photography

CHARLES MARDEN FITCH

AMPHOTO BOOKS
American Photographic Book Publishing
An Imprint of Watson-Guptill Publications
New York, New York

WITHDRAWN
KALAMAZOO VALLEY
COMMUNITY COLLEGE
LIBRARY

JAN 2 2 1991

All photographs for which no other credit is given are by the author.

Copyright © **1981** by Charles Marden Fitch.

First published in New York, New York, by American Photographic Book Publishing: an imprint of Watson-Guptill Publications, a division of Billboard Publications, Inc., 1515 Broadway, New York, NY 10036.

All rights reserved. No part of this publication may be reproduced or used in any form or by any means—graphic, electronic, or mechanical, including photocopying, recording, taping, or storage in information-retrieval systems—without written permission from the author and the publisher.

Library of Congress Cataloging in Publication Data:
Fitch, Charles Marden.
 The Rodale book of garden photography.
 Includes index.
 1. Photography of plants. I. Title.
TR724.F57 778.9'34 81-1274
 AACR2
ISBN: 0-8174-5782-8 (hardbound)
 0-8174-5781-X (softbound)

Manufactured in the United States of America

10 9 8 7 6 5 4 3 2 1

For my creative students around the world.
You are teaching as you learn,
exploring nature through a lens,
capturing insights for all.

Acknowledgments

Garden and flower photography is a highly rewarding activity, keeping one in touch with nature's beauty and bounty. Many friends assist in my study of nature around the world, and to them I send continuing gratitude. For this book, Jeff Pearson, Gary Roach (U.S.A.), and Sompong (Southeast Asia) deserve special thanks.

The photographers at the Rodale Press, and at Rodale's experimental growing fields in Pennsylvania, are skilled at picturing plants, flowers, vegetables, and gardens in storytelling or dramatic photographs. Rodale publishes books and magazines about healthy living and a natural approach to gardening, speaking to the hearts of some seven million readers around the world. *Prevention* and *Organic Gardening*, the magazines that lead the Rodale periodicals group, demonstrate how gardening with love fosters a lifestyle in harmony with nature's delicate balance.

All photographers owe thanks to international companies who are doing so much to improve the quality of films, cameras, lenses, and other tools for photography. My personal appreciation goes to the technicians and customer-service personnel of Eastman Kodak Company and of Ehrenreich Photo-Optical Industries, Inc. (Nikon Division), for answering my many questions throughout the years.

Contents

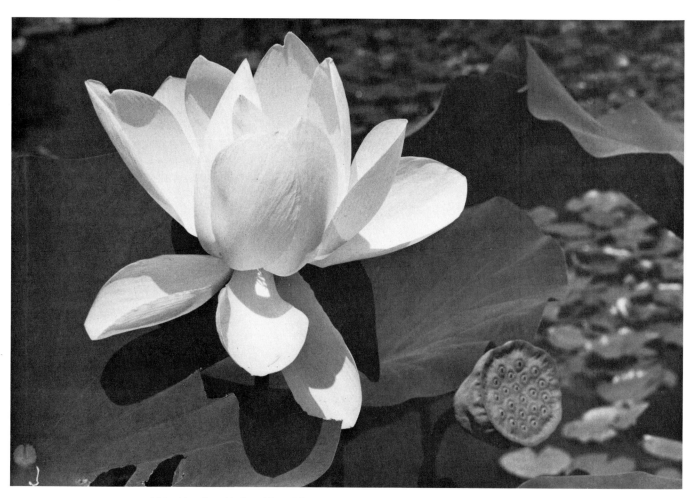

Nelumbium (lotus) is the subject of this strong composition. The print is informative, too, because it includes more than just the blossom itself. Notice how shadows add a three-dimensional effect to the petals.

1

Pleasures of Plant Photography

You must love plants and gardens if you are reading this book; so you already have a start toward creating beautiful plant photographs. Knowing about plants will improve your photographs and increase your confidence with equipment. In photography, where science combines with art, an understanding of equipment will help you get the results you want.

How does photographing individual flowers or plants differ from photographing whole gardens and landscapes? The single subject suggests portraits in which a single flower or personality of an individual plant can be captured, often in a bold close-up. An entire garden or landscape presents a more complicated aesthetic task, where multiple elements compete for attention.

As the artist, you must decide what feature to emphasize in the photographic composition. Rhythm and balance in garden photographs are most important if you want your work to be more than snapshots.

Since gardens and landscapes are generally photographed by natural light, you are dependent on the weather. For close-ups, artificial light can be added or reflectors used to di-

rect the sun; but garden views are difficult to light artificially with anything less than extensive and expensive professional equipment. Being aware of nature's moods and changing weather patterns will help you be a good garden photographer.

Subjects in close-up reveal aspects often overlooked by casual observers. A sensitive artist-scientist uses the camera to create photographs that teach and delight, combining accuracy with an aesthetically pleasing composition. The same can be done with garden views, but here each individual subject is reduced in size, subordinated to the larger subject of the scene itself.

To make a general view powerful, the photographer must pay special attention to composition, especially to patterns and directions within the frame. For example, positioning yourself where a curved flower bed will cross the view, or framing the picture with overhanging branches, can turn an otherwise plain vista into a pleasing scenic photograph.

Pleasures of Plant Photography

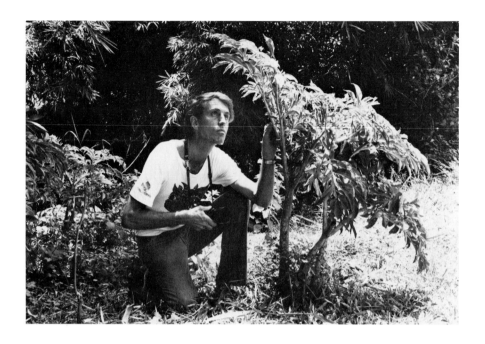

The author studies a giant witch lily (*Amorphophallus*) in Borneo. It is always interesting to get close-ups of unusual species you come across in your travels, especially in the wild.

Searching for a point of view, then a center of interest, especially one that will help to create the illusion of depth in a garden view, is a useful approach. A brightly flowered plant, or a distant bed lighted by a ray of sunshine coming through the trees, can provide a center of interest within the frame. With all plant photography, whether close or distant, the best photographers consider the *whole* frame, filling each photograph with significant detail and even making use of empty space ("negative space") to balance a composition.

Emotions

Anyone can master the basic techniques of photography, but the most powerful images are created by photographers who are involved with their subjects. Love for beautiful flowers and plants has a positive effect similar to the emotional involvement between the photographer and human subjects. The emotional response is not always love, though. It can be curiosity, fear, pity, or sensuousness. Some plants seem sinister to me, for instance, and so feelings of fearful fascination may show in my pictures of them. Other subjects may seem erotic, ugly, or powerful, and such feelings will be reflected, often consciously, in the way each subject is photographed.

Emotional sensitivity is an important personality trait of the best flower, plant, and garden photographers—in fact, of artists in any medium. Seeing with an inner eye, learning to appreciate and recognize differences in texture, substance, scent, seasonal growth patterns—all these help in the creation of meaningful photographs.

All your senses are important to you as a photographer, for they help you understand your subjects. Substance, the sound of wind through leaves, floral perfumes, color in plants and light, growth patterns are all waiting to influence the sensitive observer. By manipulating angles, lighting, perspective, film, color patterns, and other elements of composition and techniques of photography, you can express your feelings on film.

Individual Approach

Photography can be compared to painting in that one can approach the medium in several ways: a realistic style, to record accurately details of real subjects; creative compositions of high subjectivity; or even fictional compositions made by technical manipulations. Your own individual approach will depend on the reason you are making the photographs.

Scientific photography often calls for enlargement of small parts with crisp detail showing, or inclusion of a measuring device within the frame. A

garden or nature-walk diary might concentrate on general views, with seasons or the time of day being important. Plant breeders like to have close-ups showing their new creations in accurate color, while other people may prefer misty compositions with hardly anything in focus. Gardeners everywhere enjoy capturing their prize flowers, vegetables, and arrangements in technically correct photographs.

Your personal goals will thus influence your approach to photography, which in turn will determine the equipment and technique suitable for each subject. To get close-ups of small subjects, for example, you may decide to use a macro lens on a single-lens-reflex camera, while garden views and landscapes might suggest a perspective-control lens or a larger-format camera, and scientific photography might require a camera that records data on each frame.

Your favorite landscapes and garden displays can easily be captured on film. Cameras have never been easier to use. There is no reason to fuss with complicated, unwieldy equipment or to accept poor-quality photographs. By following this book's practical suggestions and techniques, you will quickly master basic camera handling and lighting and achieve success with roll after roll of rewarding photographs.

From the beginning, think about why you are taking pictures of flowers, plants, or gardens. Your methods and the equipment you need will depend upon your motives.

Why Do It?

Let's look at some reasons for photographing plants.

Beauty

Through photography you can capture the seasons, create striking flower portraits, record outstanding gardens at home and during travels. By looking through a camera's viewfinder you will improve your ability to appreciate the natural world's exquisite details of composition, variations in color, and—most important—the effect of light on your living subjects.

Home records

Including garden photographs in a family album is a lovely and useful way to remember the beauty of past years and to plan for future pleasures.

By reviewing photographs you will soon see where some new color or different landscaping plan will improve a garden design.

For a gardener, the philodendron and other large foliage plants might be as fascinating as the architecture in this photograph made in Lima, Peru.

Pleasures of Plant Photography

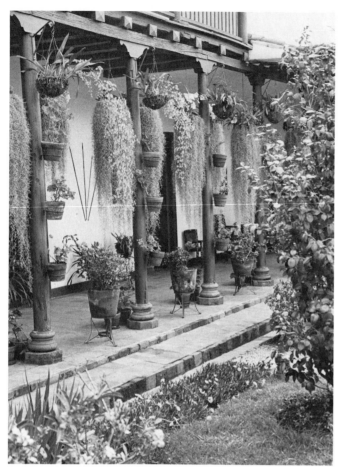

Plant photographs need not be close-ups. Here, a distinctive building and attractive plant decorations recreate the atmosphere of an old-time farm in Colombia, South America. Orchids in baskets, Spanish moss (a bromeliad), and begonias in pots decorate the patio.

A commercial greenhouse owner or nurseryman will sometimes let customer-photographers move a few plants in order to get better pictures, as shown here. This photographer's subject, a *Haemanthus* blossom, will stand out clearly against the neutral background of the earthen floor, and diffused light like this is excellent for photographing most plants.

Travel

After proving your success with the camera at home, you will be able to take excellent travel photographs, showing plants and gardens anywhere and in any weather. Since plants and landscape design are different around the world, they are important aspects of the travel experience.

Decoration

Interior designers are using more and more photographs and photographic murals for decoration. Having your own photograph on the wall for year-round enjoyment is especially satisfying. Favorite flowers, captured on film and then enlarged, will furnish a changing display at home or in your office, classroom, or anywhere you might enjoy seeing a different plant photograph every few months. The subjects might be varied according to season, holiday, or even décor.

Display and Other Uses

The appreciation of other people is a special reward for any photographer. Superior flower portraits, landscapes done in a professional manner, or unusual flora might be considered for publication, slide programs, enlargements for public display, scientific records, or personal greeting cards.

A friend who is a physician has some of my orchid portraits on display in his office. It gives me special pleasure to hear that his patients feel better just looking at these pictures. Hanging your photographs in a hospital would be a rewarding way to share your love of nature.

Your personal pleasure in growing a plant, then showing it in a photograph, can be shared with thousands of other gardeners when your work is published or projected. Plant societies who publish magazines welcome top-quality photographs that help teach and entertain readers. Some of these societies are listed in Chapter 9.

Slide talks

Slide shows can be rewarding, entertaining—or boring. If you use care in selecting only your best transparencies, then arrange them in a logical way, your programs will be welcomed by clubs and plant societies. Practical slide programs that show how to grow vegetables, do basic landscaping, even how to take better plant photographs, are valuable to schools and to horticultural organizations. It is possible to approach slide programs and publications on a professional basis, but most nonprofit plant societies cannot afford to pay more than cost for the photographs they use. Commercial publishers, on the other hand, pay professional fees for quality photographs they use in books, magazines, film strips, and on television.

Oxalis Regnellii **is one plant that opens in the daytime and closes at night. Capture it on film in both states for an interesting contrast.**

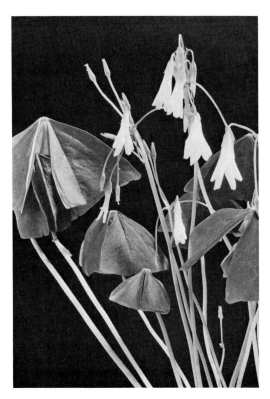 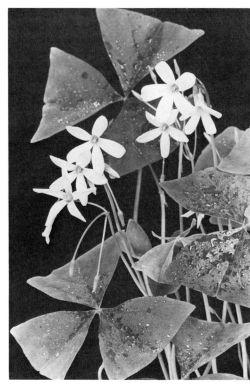

Pleasures of Plant Photography

Photographs and reference books both help when you want to determine the correct name of a species. Dr. Kiat Tan of the Orchid Identification Center at the Marie Selby Botanical Gardens in Sarasota, Florida, is seen working with a preserved specimen.

Scientific records

Anyone working with plants on a scientific level knows the value of photographs in recording plant characteristics, growth styles, diseases, and habitats, as well as keeping track of herbarium sheets and research procedures or recording the steps of an experiment. The most basic happenings—seeds sprouting, plants leaning toward light, roots growing toward water—become clearer in photographs. Experiments are easier to present for publication when accompanied by skillfully composed photographs.

14

Left: Photographs can document the progress of a windowsill garden. Hobbyists will have proof that miniature roses and African violets can flourish all winter long.

Below: Sometimes a natural event can add movement and life to a simple "flower portrait." This bee investigating *Zantedeschia aethiopica* reminds us of one floral aspect no photograph can capture: scent. The motion of the wings is too fast for even a high shutter speed to "stop."

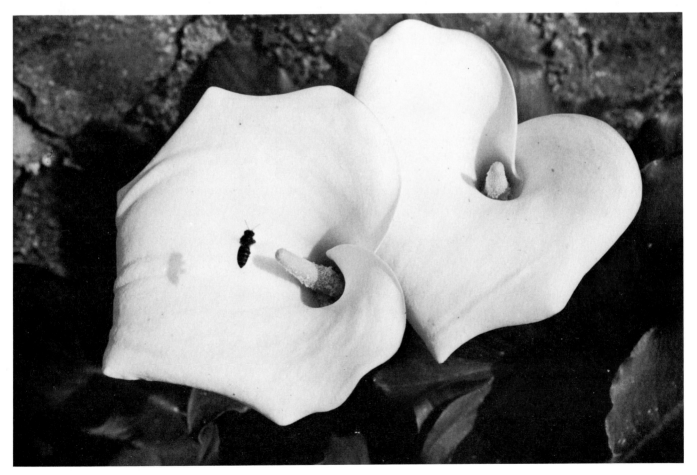

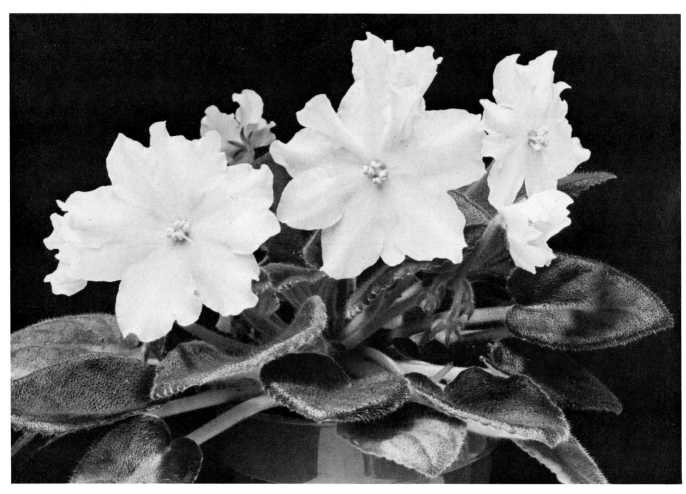

There are many uses for lovely flower pictures—in greeting cards and calendars and as wall decorations. This *Saintpaulia* 'Winter Dream' typifies appropriate subject matter.

Calendars and greetings

Calendars with 12 different color or fine black-and-white prints will greet your friends every month, rather than once a year. You might enjoy using seasonal themes, such as an ice-covered shrub for January— or the complete contrast of a tropical garden. Small calendars offered at stationery stores are easy to mount on stiff watercolor paper or art board. Mount one month to a sheet, together with your selected print.

Similarly, you can make a personal birthday card on premium quality paper, then illustrate the greeting with one of your original photographs. Fit the photograph to your friend's favorite color, flower, or tree. You can create photo greetings for any occasion on which cards are appropriate: religious holidays, engagements and weddings, birth announcements—all are appropriately illustrated with flower portraits or garden views.

Your local camera store can show you standard card formats in which your original slides or negatives can be printed. For fewer than 25 cards it may be more economical for you to have individual prints made. Fasten the prints to your own single- or double-fold cards with double-sided tape. Personal postcards are another nice use of your plant or garden photography.

Artists' records

Color photographs last much longer than live flowers; so painters can use them for reference as "permanent models". If your pictures are to be used as models for later artistic creations, be sure to photograph the plant from several different points of view so as to provide an in-depth study. A painter can compose the work so as to reveal all aspects on a single canvas. To do the same in a photograph, experiment with double exposures, mirrored backgrounds, or montages of different prints, or arrange your original composition to include a number of blossoms and foliage in several positions.

The following chapters are designed to lead you to success. It is important to select equipment that will be best for *your* work—for the way you work, for the subjects you want to photograph, and for the use you want to make of the results. Let us begin with the plans and your approach to them, then go on to the decisions that need to be made before you trip the shutter. After that we can look at the varieties of camera equipment available today, then return to the all-important subject of light and lighting. Last, we shall sketch some hints on traveling in search of photogenic botany.

Having a subject slightly off center usually improves the composition. Backlighting often looks nice with foliage plants that have thin leaves, such as this *dieffenbachia*.

2

Composition and Style

Skillful composition can reveal the personality of flowers and even of ordinary gardens in pleasing photographs. Your personal style will develop with experience and with your mastery of equipment and techniques until you can usually convey on film what you feel. Depth of field (that is, how much of the picture is in sharp focus), character of the light you choose, your favorite angle, lens choice, backgrounds, and your feeling for the subject will all contribute to the style of your work.

Readers less familiar with photographic terms may find it helpful to refer to the chapter on cameras and lenses. Since choice and use of equipment depends upon the purpose and the style of your work, though, let us begin with these subjects.

I enjoy close portrait style photography of flowers, using soft lighting, sharp focus throughout (maximum depth of field), and pastel or black backgrounds. Another photographer might prefer landscapes with the low-angled lighting of late afternoon, or close-ups of flowers with minimum depth of field.

Portrait-style medium-to-close views call for special attention to "cosmetics."

Prepare Small Subjects

Clean all the foliage and flowers that will show in the frame. If you are only photographing one cluster of flowers on a big bush, you need only be concerned with those leaves and flowers that will actually appear in the photograph. A gentle shower of plain water at the ambient temperature (room temperature, indoors) is suitable for glossy foliage, but avoid getting water on fuzzy or glaucous subjects. An

ear syringe or solder blower is excellent for blowing away bits of dirt. Stubborn soil or stains often come off with a cotton swab moistened in mild detergent. Badly marked leaves can be cut off, or held out of view with masking tape. An old toothbrush helps to clean tough parts such as stiff stems, hard succulents, plump orchid pseudobulbs.

Compose the picture within the frame of the camera's viewfinder so as to leave out any unattractive parts that cannot otherwise be eliminated. Move all around, if you can, to find the best angle. When leaves or stems interfere with the view you prefer, hold them back with masking tape or plastic-covered plant ties.

Often it is necessary to include a pot in the picture when the entire plant must be shown. Containers that look ugly can be disguised with sheet moss or with sections of plain colored paper. Clean neutral or attractive ornamental containers will not distract from the plant or flowers they hold, but overdecorated or inappropriate pots had better be hidden. Keep a supply of nice pots on hand to use as cachepots. For example, an eight-inch container made of terracotta, cork, or redwood can serve to hide an ugly four-inch pot. Put blocks of wood or foam inside if the plant needs to be raised.

"Third hands"

Some small subjects need to be positioned precisely to show important parts or to form a pleasant composition. Wire, tape, modeling clay or plasticine, and pins are great helps in close-up photography. Single flowers with a stem are easily posed with an

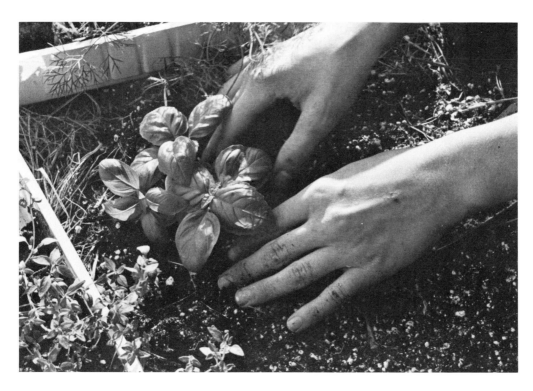

Cleaning up the area around the subject is part of the preparation for taking its portrait. This basil will show up well against the plain earthen background.

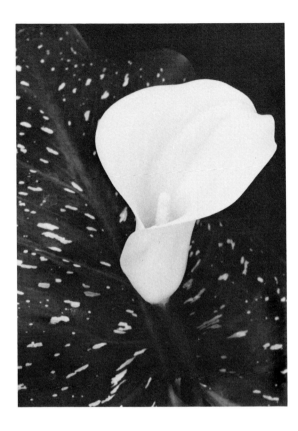

A leaf and black velvet form the background for this portrait of a calla lily (*Zantedeschia Elliottiana* hybrid). It is always appropriate to use a plant's own foliage as a background for its blossom or fruit.

alligator clip. A "third-hand" workbench grip with swivel joints is useful. Even a dowel with an alligator clamp on one end and a wooden or clay weight on the other might do.

It is possible to position small branches or sprays of flowers around or above other subjects as a compositional "frame." You will need nontipping stands with horizontal poles to which you can fasten the hanging or framing branch. Several strips of masking or gaffer tape may be needed to fasten the branch. It is annoying if part of your composition shifts before the photograph is taken.

Sometimes the whole pot must be tilted to show the flowers correctly. I use empty Styrofoam shipping containers. I tilt the pot as I set it into the container, then hold it in position with tape, wadded paper, even with big pins. Long sprays of flowers may be held in position with tape or thin string kept out of the viewfinder's frame. (A reflex camera permits precise composition, as will be described in the equipment chapter.)

Fill the Frame

Fill the viewfinder frame with only what you want see, especially for color slides. Slides are projected just as they are. For print film, either in color or in black-and-white, you can compose slightly wider—include more space around the subject—because cropping can be done when the negative is printed.

If your 35 mm photographs are to be printed by automation ("machine" prints, the common method for low-to-medium-price labs), leave some space around your main subject. The 35 mm format does not enlarge to the same ratio as the standard sizes of photographic paper: 5 × 7 inches, 8 × 10 inches, 11 × 14 inches. Some cropping is almost always done at the long ends (sides, in

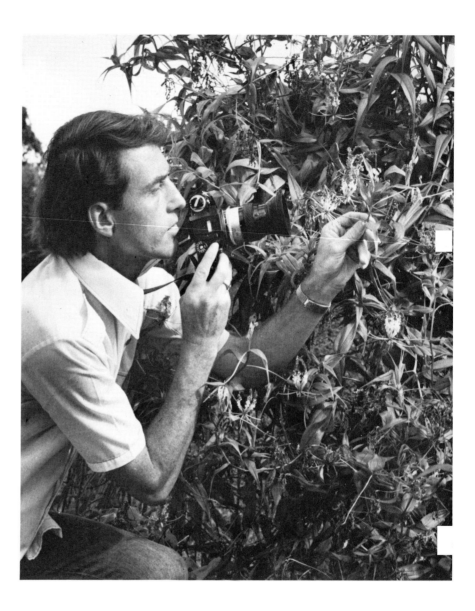

When using a macro lens for a close-up, it may be necessary to hold the flower in the right position. Including fingers in the composition can indicate size. Photo by Sompong.

horizontal photos) when borderless prints are made by machine. In fact, the usual machine prints crop some of the 35 mm frame even when prints are made with borders. If you compose tightly and wish to have all of the image printed, specify "full frame" when placing your order. A custom laboratory will follow your instructions for exact "cropping," or trimming of the picture.

Show Size

In close-ups you may want to show the actual size of the subject. With scientific photography it is appropriate to include a ruler in the picture. In other styles of photography, the ruler often looks too clinical. Size can be demonstrated more artistically by including an object of known size for comparison: a ring, teacup, pen—even a hand will serve. Arrange the object to be in focus, but compose your photograph so the object does not distract from the main subject.

Small potted plants and miniatures of all kinds look handsome when held in the palm of a hand. An assistant or friend can help by holding your subject. With really small flowers close to the lens it is possible for the photographer to put a finger or two next to the subject.

Outdoor Subjects

Composition in landscapes quickly separates a careful photographer from the casual snapshooter. A beginner backs off to show everything in one shot, or purposely avoids foreground branches that are "in the way." An experienced photographer creates depth and interest by carefully *selecting* the point of view, then often frames the main subject with foreground material.

Flower borders set in a lawn are beautiful to see live but can appear dull when photographed casually head-on as one-third sky, one-third flower bed, and one-third lawn. Move around until you see the plants in curves rather than in straight lines; or take the photograph from slightly

Search for contrasting patterns in nature, and then compose according to your own taste. Here, intricate maple foliage and broad-leaf evergreens form interesting patterns at Meiji gardens in Tokyo, Japan.

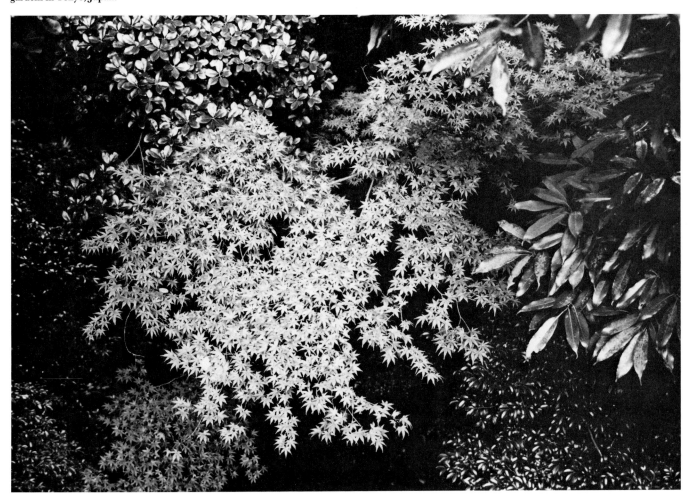

Composition and Style

The lovely curve of the flowers and path leads the imagination deep into the summer display at Huntington Botanical Gardens, near Los Angeles. This part of the gardens is planted with flowers and herbs common in Shakespeare's time. The famous Huntington Library and Art Gallery are nearby.

behind overhanging branches to create an impression of three-dimensional depth.

You can place interesting patterns against the sky. You might even hold a branch in front of the lens to form a frame where none grows.

In color, out-of-focus flowers and foliage look nice around a sharply shown central subject. ·

If your camera has a depth-of-field preview, use it to check each effect.

Filters help control tones in black and white (see Chapter 5). With color films, the polarizing filter can greatly improve landscape photographs by reducing reflections and deepening colors, such as the blue of the sky.

Shadows

In black-and-white prints, shadows can form an important part of the composition, especially where there is little or no difference in tone to help distinguish between various shades of color—between green and blue, or yellow and pink.

Shadows can make subjects stand out from the background or add a note of drama. Look for the shadows before taking each photograph. Sometimes the plant shadows themselves are interesting and well worth including in the composition.

Shadows are often a disadvantage in close-ups if they hide parts of the flowers. In landscape photography, though, shadows more often help to balance the composition or even hide areas you would rather not show (see Chapter 7).

If some parts of the composition look too dark, lighten the shadows with reflectors (as demonstrated in Chapter 6, on lighting) or wait until the sun's direction is more pleasing for the picture you had in mind.

Tree silhouettes are dramatic in color against blue skies, sunsets, or interesting clouds. In black and white they usually have more power when the background is plain.

Shadows can be important elements in a composition, especially in black-and-white pictures. At *right above*, they add geometrical elements that emphasize the fountain at the end of the rose arbor at Huntington Botanical Gardens. *At right,* the broad area of lawn would be dull without the contrasts of light and shade. Notice how the branch at left parallels the shadow that leads the eye toward the right-hand statue (also in Huntington Gardens).

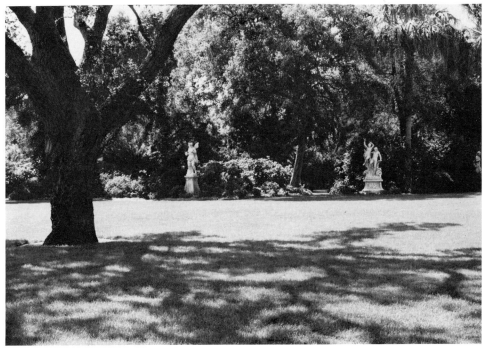

Composition and Style

Showing depth in landscape photographs requires careful composition. Deep perspective has been created by shooting through an opening in the dense vegetation, yet the slope of the mountainside, tree varieties, and distant misty jungle provide information about tropic high-altitude conditions (3000 meters, nearly 10,000 feet) in Costa Rica.

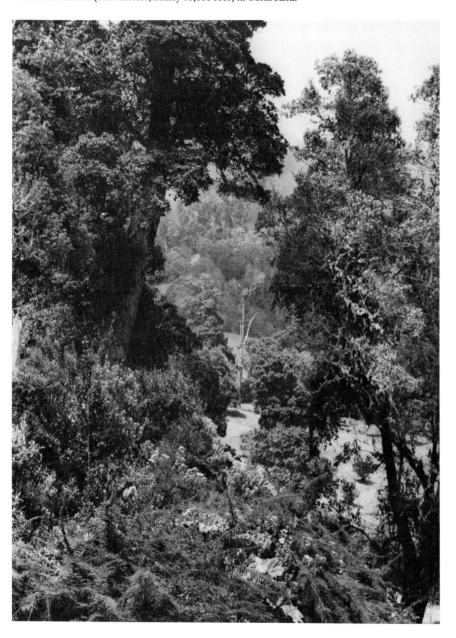

Perspective

Create depth in your medium-to-wide landscapes by including receding lines such as curved paths, graceful borders, or trees at various distances. Straight lines tend to be boring, but curved forms often improve composition.

A wide-angle lens used close to some important subject, such as a flowering shrub, can dramatize the nearby object while still revealing parts of the garden. A telephoto lens does the reverse by narrowing the angle of view, compressing subject matter, and reducing depth of field. With the 35 mm format, a lens of 100 mm to 200 mm in focal length is ideal for isolating specimen plants and for showing tall trees from a distance, thus reducing the tilted-back look caused by tilting the camera upward. When you have enough room to move back, filling the frame with a telephoto lens, trees look more natural.

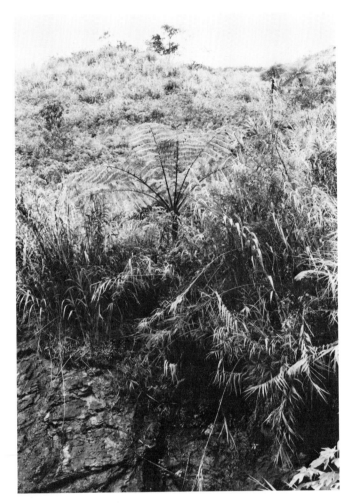 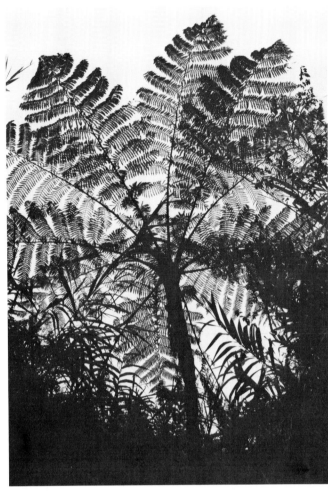

On the *left, above,* **a Philippine tree fern is shown accurately in its mountain home on Luzon, but there is little pictorial interest. On the** *right,* **the same fern has become a dramatic design that would make a striking wall decoration. Botanical interest has not been lost, either, because the fern's structure is clearly visible.**

Of course, a dramatically different perspective can emphasize height. There may be times when you *want* to use a wide-angle lens (35 mm down to 16 mm, on 35 mm cameras) close to a tree trunk from a low angle of view. The ultimate example is an extreme-wide-angle, or "fisheye" (8 mm or wider) view looking directly up at tall trees, which is certainly not a routine portrait.

There are now a number of perspective-control lenses for 35 mm single-lens reflex cameras. I use one to eliminate the unnatural convergence of straight lines you get with tall subjects when there is no room to move back and the camera must be tilted, as with those tall trees. Perspective-control lenses are very expensive, but they do permit you to keep perpendicular lines straighter and also to shoot around objects that might otherwise ruin your composition. For example, a tree trunk, garden orna-

ment, sign, or fence can be placed out of the frame by moving a knob that shifts the lens even though the camera body does not move. (More about lenses later, including a series of perspective test shots in Chapter 3.)

Some Special Effects

Blur

Showing motion is one way to create unusual photographs. Here are two ways to do this.

1. A slow exposure during windy weather turns swaying flowers into blurs.
2. A zoom lens zoomed during a long exposure (between 1/8 second and 1 second) creates a "tunnel" effect: sharp center and blurry sides, highlighting whatever is in the sharp center. In color portraits against a black background, the zooming brings color into the whole frame.

Depth of field

To isolate a single subject and subdue the background, use a shallow depth of field, as follows: Compose your photograph to concentrate on the subject, select a large f-stop (lens opening, or aperture)—between $f/4$ and $f/1.2$, or your camera's largest opening—then check the effect by activating the depth-of-field preview. If not enough of the subject looks sharp, close the lens down (turn to smaller f-stops—the larger f numbers) while watching the depth of field increase. With this technique you can photograph a whole field of flowers but put the emphasis on a single blossom. In close-ups, you can emphasize a single part of the flower or plant.

Depth of field is a very important concept, which will be referred to again and again in this book.

Backgrounds

"Behind every subject is a complementary background." If this is true in your photographs, congratulations! Most of us must *make* the complementary background, using a combination of preplanning and technical expertise.

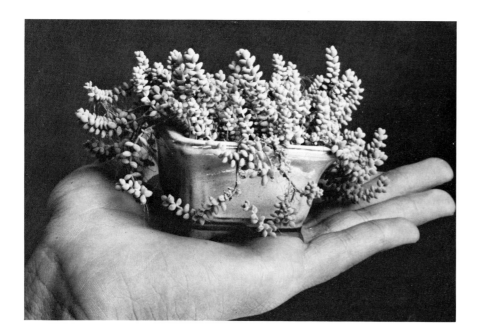

The hand furnishes an amusing support while subtly stating the tiny size of this miniature sedum.

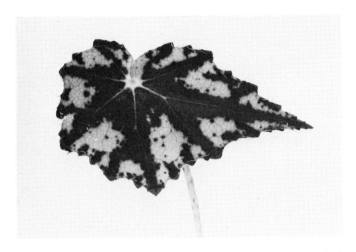

Important features can be brought out or lost, depending on backgrounds. At *left, above,* the leaf of *Begonia boweri* 'Nigromarga' shows its shape and its color pattern clearly against the light background. At *right,* however, against the dark background delicate silvery hairs suddenly assume importance.

Small subjects

Backgrounds for small subjects are the easiest to arrange. When the background is to be completely neutral, a black or white card, wrinkle-free cloth, or seamless paper is suitable. The choice will depend on the subject and on the intended use of each photograph.

Flowers and plants with light edges, fine white or silvery hairs on their edge, and generally light colors show best on black. For example, light yellow forsythia flowers, white snowdrops, or some gloxinias with silver hairs all over the flowers are more dramatic against black. If they are photographed against white, it is difficult to see important characteristics.

In contrast are flowers with dark hairs, such as some paphiopedilum orchids, subjects with medium-to-dark colors, for instance deep red roses, green foliage, and subjects where space between parts should contrast fully with the form, such as tree branches or intricate arrangements of dark flowers or leaves. In these cases a white background will help produce a revealing, dramatic photograph.

Position subjects far enough in front of light backgrounds to avoid having shadows showing behind. With black backgrounds, the black is usually so underexposed that shadows are hidden; but even with dark backgrounds it is safer to keep subjects far enough in front so that shadows fall free or to the side, unless you wish them to show for effect.

Composition and Style

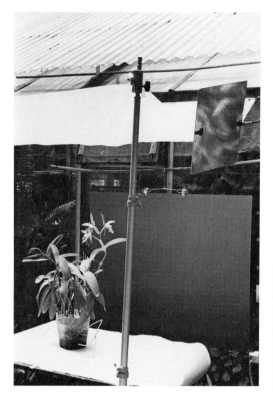
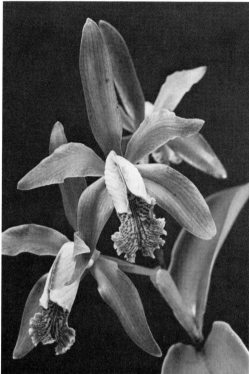

In this outdoor "ministudio" arranged around a table in front of the greenhouse, sunlight is diffused by an overhead plastic fabric. Dark blue mat board hangs behind the subject. At upper right, a reflector (Lowel-Light's Tota-Flector supported by a Flexi-Shaft) redirects some light onto the shaded underside of the blossom. The final photograph, *at right*, shows *Cattleya* Source d'Or flowers clearly defined. The background could have been made lighter by bouncing more light onto the mat board.

Cloth and foam

Fabrics of wool, cotton, and other nonreflective surfaces are suitable as backgrounds. A glossy reflective background would only be used for special effects. Velvet has a suitable texture if either kept flat or well rippled or in graceful curves. It can give an air of luxury, perhaps with arrangements of flowers in silver or crystal containers. For a smooth background without creases, choose flat wool material or a similar fabric that will hang flat and resist wrinkles.

Although many fabrics resist creasing, I have yet to find a fabric background that can be folded for any length of time without developing wrinkles. Hang your fabric backgrounds full length for storage, or gently roll them around a cardboard tube or similar core to keep the material from creasing.

Besides cloth fabrics, foam rubber material is useful as a background for flowers and plants. One type, called Foam-Ett (from the B. & D. Company, Erie, PA 16512) is a thin, nonreflective rubber sheet 60 inches wide. Like a theatrical scrim, the material is so thin you can see through it when the light is behind, but when lit from the front it shows as a plain-color background of white, red, or deep black. Since this foam rubber fabric is delicate, sew a thick hem along one edge so that hangers can be attached without tearing it. An advantage of this foam rubber material, and of many cloth fabrics, is that they can be draped over and around stands, pots, and background objects more easily than seamless paper can.

Seamless paper

Rolls of seamless paper are offered through photographic suppliers and camera stores in at least 30 different colors, including superwhite and deep black. Wide rolls are 2.7 m (107 in.) wide by either 10.9 m or 46 m (36 or 150 ft) long. Narrow rolls are 1.3 m (52 in.) wide by the same lengths. Most useful for home plant portraits are the rolls 1.3 m wide by 46 m long. These can be made even narrower by sawing the roll. Some art-supply

stores also offer sheets of background material.

Efficient holders are available to support the roll of paper. Or you can cut off a length of the paper and hang it or tape it behind and over the work table where you place the subjects.

Interesting shadows can form part of your composition, or the background paper can be kept shadow-free by careful placement of both lights and subject. To keep shadows off the background, place the subject 60 to 90 cm (about 2 to 3 ft) in front of the background section. The area under a pot can be kept almost shadow-free by using diffused lighting, as explained in Chapter 6.

Translumination

For a floating effect, place the subject on a translucent background, such as an acrylic table covered with diffusion material, and light it both from behind and from the front.

To light only a portion of a plant, it is much easier to use the *trans-lumination* technique. A clear pane of glass covered with tracing paper, frosted glass, or one of the professional translucent diffusion materials can form the backdrop. Light the subject from the front, then place enough light behind the diffusion background to make it appear as a sea of plain white. A light box with a smooth surface or an x-ray-viewing box can also be used.

An adjustable stand supports roll of seamless paper behind a kapok-bearing ceiba tree. Lighting was a 1500-watt floodlight and a 1000-watt umbrella device (see Chapter 6).

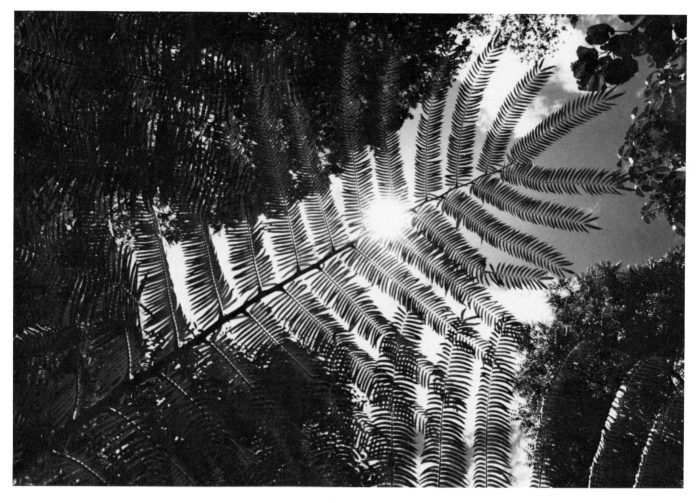

Translumination—light shining through the subject—can add emotional impact. A frond of the giant tree fern *Angiopteris evecta* seems to filter the sun.

Varying the intensity of the front light in proportion to the diffused background light will change the look of each exposure. Use stronger background light coming through the diffusion material if you want to show veins in a flower or leaf.

For color photography, putting a colored gel over one of the background lights will soften the hue. This works for translucent backgrounds, but if the light is too strong the colored light may have a distinct effect on the subject. For seamless paper backgrounds or background cards, the colored light will not color the subject if you keep a distance 60 cm to 90 cm (2 ft to 3 ft) between subject and colored area.

Some flash units accept accessory colored "filters" and others can have colored gels taped directly over them. Much warmer incandescent studio lights can be tinted with heat-resistant gels held far enough in front of the lamp to keep the gels from melting.

A spray of *Angraecum* orchids is positioned in front of a board that has been hand colored with pastel crayons. Silver reflectors under the flower fill in shadows by redirecting light from the light sources at the left and above right; at right, a tripod holds the camera vertical. Small alligator clips on a weighted small-parts-holding device support the orchids.

Art board and canvas

If you seldom show the whole container or an entire plant on a neutral background, a stiff art board hung or propped behind the subject can substitute for seamless paper. The matting cardboard sold by art-supply stores and picture framers comes in many colors. When you need to show only the top portion of a plant or a spray of flowers, there is no reason to use seamless paper continuing under the whole container. An assortment of mat boards in different colors is easy to store. The standard size is 32 × 40 in. (81 × 102 cm) and can be cut to any size. Different surfaces are offered, but nonglossy is the most versatile for plant backgrounds. The reverse side of most brands of colored boards is white, and so can double as a noncolored background or as a reflector (as described in Chapter 6, on lighting, and Chapter 7, on outdoor techniques).

Mat board is also offered in different textures and surfaces, such as burlap, grasscloth, linen, or silk. For brilliant "psychedelic" effects, perhaps when using prisms, consider the fluorescent poster board offered in many art stores, or the gold and silver

reflector material sold by professional photographic stores and manufacturers such as Rosco Laboratories, Inc., of Port Chester, N.Y. For texture variation, try canvas.

For a personally created background, paint a mat board or canvas with colors complementary to your plant subject, or paint in big, fluffy white clouds. Try applying paint with a sponge, with bold brushes, and by spraying. Each technique creates a different look. These painted backgrounds may look too artificial or distracting when photographed in sharp focus. Place the background card well behind the subject to keep it out of focus. This is not difficult with close-ups. The depth-of-field preview will show you what the final effect will be.

Projected backgrounds

Professional portrait studios often use special projectors to throw a slide image from the camera position onto a background. This projected view—a mountain, perhaps, or fence in a field—serves as a background behind a person placed in front of the screen. Few hobby photographers want to spend the thousands of dollars these front projectors cost. A similar effect

A reflective background (Mylar) adds an impressionistic touch to the portrait of a *Catasetum pileatum* orchid.

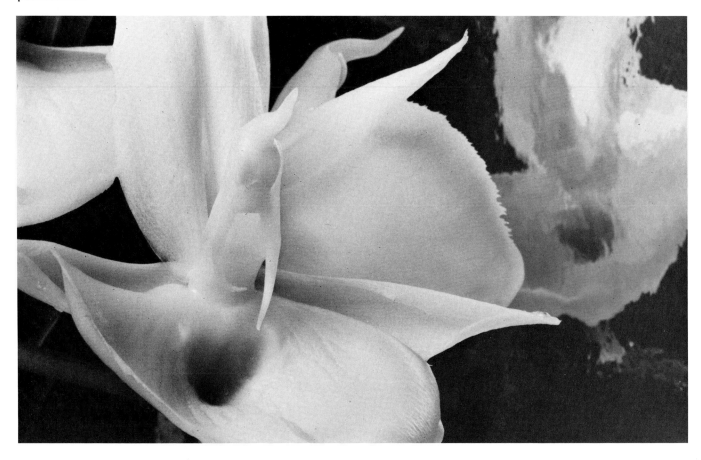

An environmental background is suitable for plants growing in or near water. Here a *Hymenocallis* "poses" in a pond in Singapore. A yellow-green filter turned the blue reflection dark (see Chapter 5).

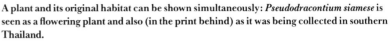

A plant and its original habitat can be shown simultaneously: *Pseudodracontium siamese* is seen as a flowering plant and also (in the print behind) as it was being collected in southern Thailand.

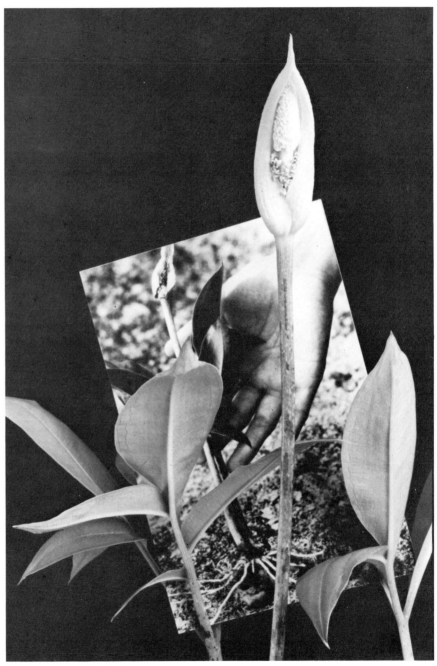

can be created by projecting slides in a home slide projector from an angle, so that the image from the slide does not hit the subject but only the background (a white matte surface, such as mat board, is best here). The other choice is to use a rear-projection technique: The slide is projected *through* a frosted section of glass or tracing paper, or a rear-projection screen such as those made by the Da-Lite Screen Company of Warsaw, IN, *behind* the subject.

With a projected background, be sure to arrange the lights on the subject without having much spill onto the screen or the rear-projection material. Barndoors and grids over the

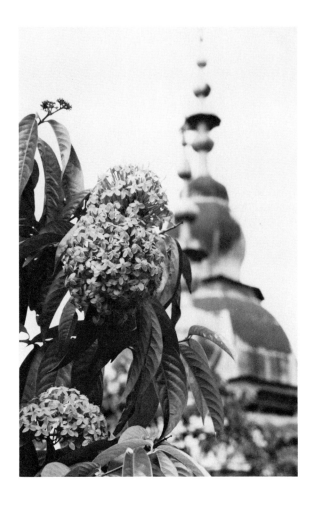

The out-of-focus mosque in the background hints at the Indonesian habitat of this *Ixora* shrub, which has bright red flowers.

light sources are useful here. Naturally, the lighting of the background slide and the lighting on the subject must be equal to achieve good exposure for both.

Double exposures

If both methods just described are too difficult with the projector or the lighting equipment you have, experiment with a double exposure, if that is possible with your camera. (Some modern single-lens reflex cameras permit precise double exposures, others do not.)

First, with the camera on a tripod photograph the subject, well illuminated, against a black background. Without advancing the film or moving the camera, reset (re-cock) the shutter, then project the background slide and make an exposure that is correct for that *background*. If you are projecting so that the slide does not hit the subject, leave the subject in place for both subject exposure and background slide exposure. The only difference will be that when you take the background exposure, your subject will be dark.

Environmental backgrounds

Another way is to use one of your photographs as a background. Have a big enlargement made, mount it on board, and use it instead of a projected background. Suitable background views include sky with clouds, lawn with flowers along the edge, or jungle or woodland foliage, perhaps slightly out of focus.

You might want to use the actual environment around the plant subjects as a background. Attractive fur-

niture, the outside of buildings, fences, and lawn can be arranged in the composition to complement the plants. Study the finder image carefully, using the depth-of-field preview, to make sure the environmental elements provide a suitable background.

Some of the most beautiful houseplant and garden photographs are medium-distance views with a combination of furniture or buildings and plants. Still, some of the *least* effective plant photos I have seen result from using a "natural" background. Just because a plant grows next to something or in a certain room does not mean the photographer has to include unattractive or distracting elements in the photograph. Portable backgrounds and depth of field are your controls over the environment around each subject, indoors or out. Lighting can also be used to place attention on important subjects while subduing the background.

Image size and depth of field

There are times when the background you want to use will not fill the frame behind your subject. The normal lens has a moderately wide angle of view, which may be too wide when you only have a 60 cm × 90 cm (2 × 3 ft) background card or cloth. When this occurs, switch to a longer lens that will render the image in a relatively bigger size: In 35 mm photography, a lens with a 105 mm focal

This ***Chrysanthemum Parthenium*** was photographed from slightly different angles: against other flowers that are out of focus but hint at a whole gardenful; *far right,* against a dark background especially effective in black-and-white photography.

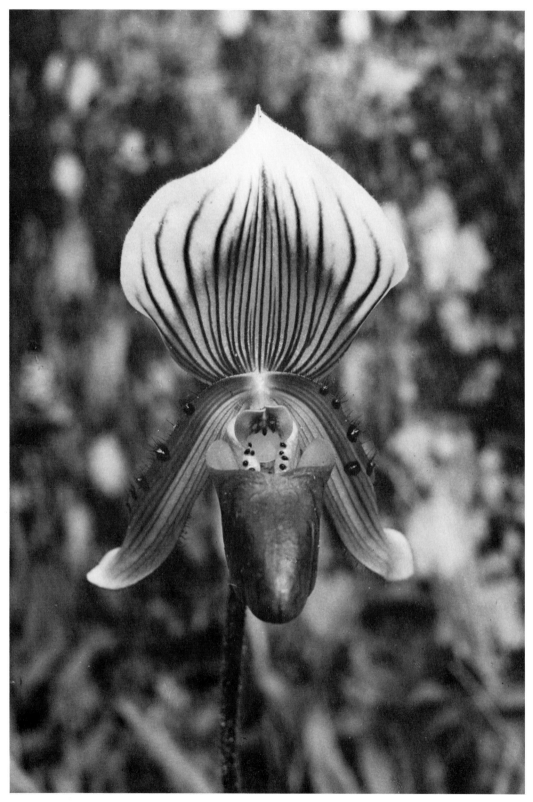

A background that could be confusing can be reduced to an indistinct blur by the use of a wide lens opening. In contrast, this Thailand *Paphiopedilum callosum* is seen sharply.

length, or a zoom range between 70 mm and 150 mm, will let you fill the frame with these medium-sized backgrounds. (See Chapters 3 and 5 for more about image sizes and focal lengths.)

The depth of field, or zone of acceptable sharpness, decreases as the lens is focused close. A glance at the depth-of-field lines on most lens mounts, or at the tables that come with close-up accessories, will confirm this. Depth of field is influenced by the distance from lens to subject, getting shallower as the camera nears the subject. It is also influenced by the *f*-stop, with the smallest openings producing the greatest depth of field. Changing lenses will alter the depth of field in a composition because each lens will render the subject in a *different size* when used from the same shooting position.

Using a 2 × telextender/converter (described in Chapter 5) will also increase the image size (by narrowing the angle of view), as it changes the the effective focal length of a 50 mm lens to 100 mm. Once again, the single-lens-reflex design becomes important in letting you see just what the final image will look like.

Now that we have taken a look at the whys and some of the hows of garden and flower photography, let us review the "with what" before we go on to the actual doing of it.

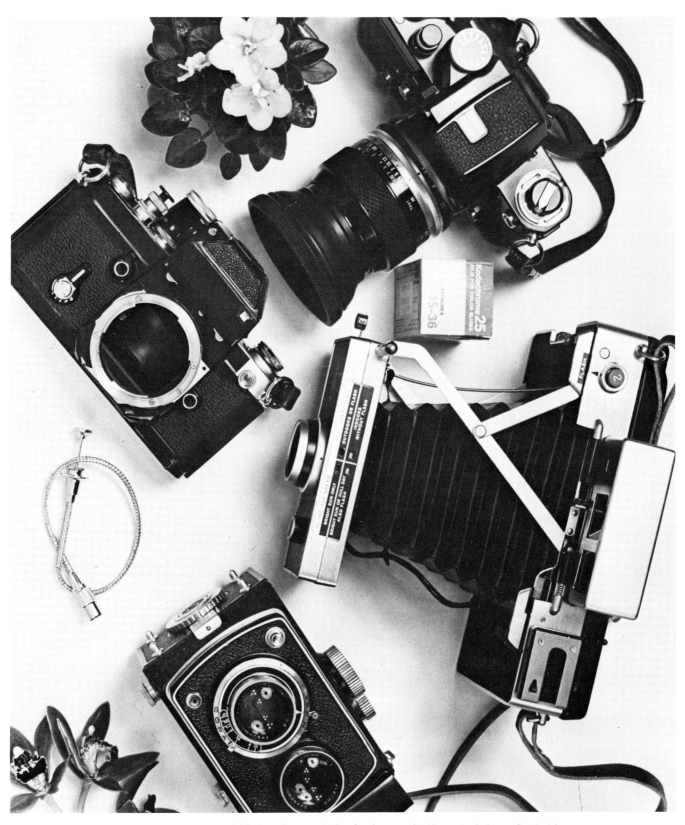

Several types of cameras can be used for plant photographs, but for close-ups the 35 mm single-lens reflex (*top*) is the most versatile. The lens has been removed from the SLR camera at upper left to show the mirror inside. Most cameras of this type have interchangeable lenses. The Polaroid Land camera (*right*) provides instant prints. The twin-lens-reflex design (*bottom*) is easy to focus and is excellent for medium-to-wide views. A cable release (*left*) is used to release the shutter without shaking the camera—a blessing when exposures must be slow.

3

Camera and Lens

There are many different kinds of cameras. Even within the same types you will notice variations in size and placement of controls, methods of view-finding, methods and control of exposure-metering, availability of accessories. Even under one brand name a manufacturer may offer several model with different features, weight—and price.

Before choosing a new camera, decide how much you are willing to spend, then list the features you want, beginning with types. A checklist appears at the close of this chapter. Then visit a camera store or photography show and handle various models. One person may prefer a lightweight camera while another likes a hefty one. Some photographers want totally automatic cameras that set shutter speed and f-stop, while others prefer to control the metering system by adjusting a needle or diode lights. Some cameras offer both automatic and manual options—more about this later.

Remember to budget for accessories such as filters, tripod, cable release, perhaps a flash unit.

Most important, the camera you choose should be suited to the type of photography you want to do.

What is the major use of your photographs? What size are your subjects? Where will you use the camera? Do you want slides for publication or projection? Are color prints required? Do you have a specialized professional need for a large format or a view camera with swings and tilts?

Camera Types

Camera sizes or formats are generally referred to by the size of the film they use. Even most professional plant photographers today seldom need to use a camera larger than 35 mm unless they make photographs for specialized markets such as mural makers, calendar publishers, and architects, which may call for 2¼-inch-square or 2¼ × 2¾-inch (6 × 7 cm) or larger images. In fact, nowadays the larger formats have one major disadvantage: The best color transparency film, Kodachrome 25, is not available in sizes larger than 35 mm. Larger cameras are also more awkward in the field, although they are convenient when used on a tripod or in a home garden or studio setting.

35 mm single-lens reflex cameras

All the popular uses of plant photographs, whether black-and-white or color, can be served with modern 35 mm single-lens reflex cameras: teaching photos, illustrations for publication, decorative display, slide programs.

When shopping for a camera, compare workmanship and versatility, as well as price. Here again the 35 mm single-lens-reflex models come out ahead for plant photography. Most of the popular 35 mm SLRs are now lightweight and compact in design, allow for change of lenses, have accurate built-in exposure meters, allow you to use either automatic or manual settings, and accept a wide choice of accessories—at a relatively reasonable price.

The choice of film is extensive in the 35 mm size, and it is available in most towns around the world. (See Chapter 4 for more about film choice.) Support equipment, such as tripods, electronic flash units, cases, filters, is abundant. Most of the color photographs in superior international magazines like *National Geographic* and *Geo* are made with 35 mm single-lens reflex cameras.

Smallest format

For hobby use, the smallest practical format is 110. When prints are the main requirement, a 110 camera loaded with medium-speed negative film will yield prints acceptable for the family album and even enlargements up to 8 × 10 inches. Cameras in the 110 format include both simple and complex models by Eastman Kodak and other manufacturers and single-lens-reflex designs by Pentax and Minolta. The latter even makes an underwater 110. Film in 110 size is supplied in drop-in cartridges. Insertion of the cartridge into the camera also programs the built-in meter for the correct ISO rating, or film sensitivity.

Roll-film cameras

Two varieties of camera that produce 2¼-inch-square pictures on size 120 or 220 roll-film are suitable for general garden and landscape photography. Two disadvantages of both are that Kodachrome film cannot be used and that a special projector is needed for 2¼-inch-square slides.

Twin-lens reflex cameras. Making close-ups with twin-lens reflex cameras is not as precise and is more time consuming than with single-lens reflex models. The photographer focuses through the upper lens, but the lower lens actually makes the exposure. The difference in spacing between the two leads to a problem called *parallax*.

Advantages of the twin-lens reflex are easy, bright focusing, usually from above, a bigger negative, a wide choice of shutter speeds that will synchronize with electronic flash. *Disadvantages* are that there is no direct through-the-lens view, that equipment is heavier, and that the lens choice is restricted. Even models with interchangeable lens boards have less versatility than the single-lens models.

Large single-lens reflex. Besides the twin-lens reflex, one might consider

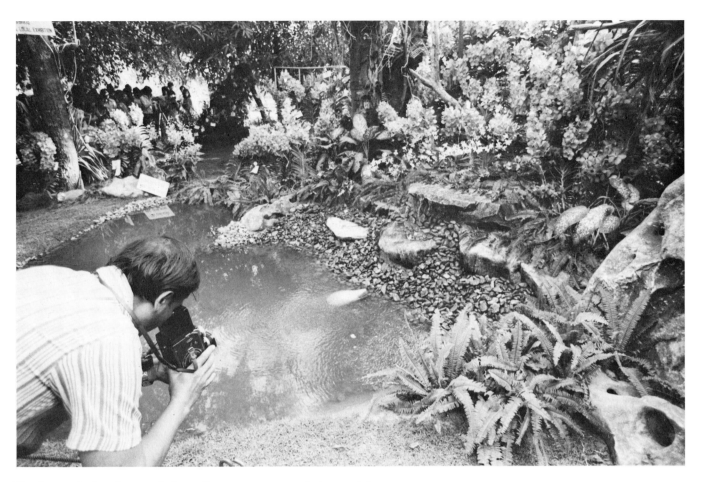

The photographer has chosen a twin-lens-reflex camera to capture the beauty of plants at an outdoor orchid show. This camera design lets him get a low angle easily, since viewing is done by looking down onto the focusing screen from above.

the larger cameras with single-lens re-flex design, such as Hasselblad, Bron-ica, and large Mamiya SLRs. These use 120 or 220 roll-film and give pic-tures 2¼ inches square or larger. Most of these cameras have a good choice of lenses, and they are also easy to equip with filters, cases, lens shades, and similar accessories. Because you focus through the taking lens, you do not have the parallax problem that plagues twin-lens camera users mak-ing close-ups.

View cameras

In a few cases, a professional pho-tographer will want to have full con-trol over perspective. If you plan on specializing in photographs of gar-dens or of tall buildings or both to-gether, then a 4 × 5 or larger format *view camera* is worth considering. These have glass focusing screens, use sheet film, and do not need supple-mentary lenses to correct perspective. The latter makes them favorites with architectural photographers, but it is not needed by most plant photogra-phers. Naturally the larger films cost more money than 35 mm or 120 films

(two 4 × 5 sheets of film are equiva-lent to one roll of 36-exposure 35 mm film).

Rangefinder cameras

Within the 35 mm format one can obtain rangefinder cameras that are suitable for medium-to-wide views, but the rangefinder design is not con-venient for precise close-ups. In a rangefinder camera the focusing and viewing are done through a window

above the taking lens, and the same problem mentioned above with twin-lens reflex cameras—*parallax*—is present. Since you are not viewing through the taking lens, it is impossible to preview depth of field or to see the effect of filters. Since the lens must be coupled to the rangefinder for correct focusing, the choice of lenses for rangefinder cameras is much less than for single-lens reflexes.

The main *advantages* of sophisticated rangefinder cameras are their ease of focusing and viewing even when the light is very dim, and their very quiet operation. Neither is of much importance to plant photographers.

Simple cameras

Inexpensive 35 mm or similar cameras, including some 110 and 126 film size instant-load types, are suitable for general photography in the garden when no close-ups are required. With simple cameras, the viewing is usually done through a plain viewfinder, which has no connection to the lens and so no rangefinder (distance indicator). Focusing is thus not very precise, if it is possible at all. The markings on some cameras show a distant mountain range for far focus, a big tree or a group of people for me-

dium distance, and one person's head and shoulders for closest focus, usually about one meter (3 ft). With many models a flash can be added for direct front light. When one is photographing objects that are always the same size, such an arrangement may be satisfactory; but for advanced garden photography, and especially artistic flower portraits, it is impractical.

These simple cameras are not suitable for anyone who wants control over the end results. In a few rare cases a simple camera can fill a specific close-up goal when the camera is equipped with supplementary close-up lenses and some sort of frame to show the photographer what field of view will be covered with each supplementary attachment.

Instant-picture cameras

The most popular cameras to accept instant-picture films are those made by Polaroid and by Kodak specifically for their own instant-picture films. They are suitable for hobby use but are seldom considered for professional plant photography. They can be most useful for medium-to-wide views when a print is needed at once.

Special camera backs made by Polaroid can be used on sophisticated large single-lens reflex cameras, such as the Mamiya RB-67 and the Hasselblad. These can be very useful for checking lighting or other effects.

There is also a device that fits Nikon 35 mm cameras, adapting them to use Polaroid Land film backs; but it is heavy and expensive. If you plan on using instant-picture film frequently it would be wiser to get one of the larger cameras that accept instant-film backs.

In the past color quality in instant-picture color film has not seemed as true, to most people's eyes, as that in other color films. Recent refinements in the materials may change this, however.

Most instant-picture film cannot produce both a negative and a print, although Polaroid does have black-and-white film that gives a good print plus a negative for each exposure.

Metering Systems

Modern cameras, especially 35 mm SLR models, usually come with built-in exposure meters, whether or not they are automatic. The meters in these cameras generally measure light from behind the lens and are called "BTL" ("behind-the-lens") or "TTL" ("Through-the-lens") meters. Systems that measure light from outside the camera are less desirable because they do not "read" through filters or other in-front-of-the-lens attachments. Also, often they "read" too much sky when one is photographing landscapes. The TTL meters measure only the light that will actually hit the film inside the camera.

Behind-the-lens meters vary as to their areas of sensitivity. Some are

equally sensitive all over and *average* the readings from both light and dark subjects within the whole frame. Others are *center-weighted*, reading all parts but giving preference to whatever is at the center of the finder screen. A third type reads only what is in a limited *spot* in the viewfinder. Each of these systems is useful in certain situations. Some cameras permit the photographer to switch from one system to another.

Most SLRs have some sort of metering information available in the finder window. This lets you check *f*-stops and shutter speeds without having to look away from the viewfinder. Since almost every camera has a different method of showing this information, from winking lights to wavering needles, you should study the system in several models before making your final choice. The important thing is for the photographer to understand what information the meter offers.

Before trusting your camera, read the instruction book and take test photographs to understand how the meter functions. (Chapters 6 and 7 have some suggestions about using meters in different situations.)

Automatic vs. Manual

Some cameras provide for automatic exposure. Three systems are available in 35 mm SLR formats.

- *Aperture-preferred* (also called *aperture-priority*) requires that you set the *f*-stop (lens opening, or aperture) you want. The camera then automatically sets the shutter speed.
- *Shutter-preferred* (or *shutter-priority*) requires that you choose the shutter speed. The camera automatically adjusts the lens opening needed to get the picture at that speed.
- Some modern SLRs offer a choice of both automatic modes *plus* manual control.

Automatic exposure is useful for action photography but is seldom helpful with still-life compositions, landscapes, or flower portraits. With manual control one can get good results with backlit subjects, very dark or very light subjects, and with any shade of background. Automatic exposures in these situations are often overexposed or underexposed because the meter is fooled by unusually dark or light areas within the viewfinder frame.

Where automation is useful

In a few plant or garden photography situations some form of automation will let one work faster, perhaps obtain photos that could be difficult to get with a manually adjusted diode light or match-needle meter control. Field photography, where the light changes rapidly, is an example: When traveling down a river photographing plants along the bank, with some areas in sun and others in shade, an automatic camera would be efficient because it could adjust for the rapid changes in light faster than would be possible with manual control. In such a case, shutter-priority automation would be preferred, so that one could select a motion-stopping shutter speed.

If one wanted to use a motor drive with an electric timer for time-lapse photographs in natural light (for example a plant sprouting or a flower opening), taking one frame every five minutes, an automatic camera would be ideal as it could adjust for any change in the intensity of the illumination. (A nonautomatic motor-driven camera would be suitable when electronic flash or other light system provides a constant, predetermined quantity of light for each exposure.)

In all cases, it is valuable to have a complete manual override option, no matter what other exposure modes a camera model may offer.

Camera and Lens

Self-timer

Many 35 mm cameras come with built-in self-timers. If you plan on doing slow exposures or wish to include yourself in photographs, choose a camera model that includes a self-timer. Accessory self-timers are available, but it is quicker to use the built-in types. Most self-timers offer a range of shutter-release delays, and some can be varied over a range of 2–10 seconds. If you must make slow exposures without a cable release, the self-timer will let you release the shutter without causing camera movement: Between the moment you release the timer and the moment the timer makes the actual exposure, any vibration you may have caused to the camera will have ceased.

Depth of Field

It is helpful to be able to see how much of your finished photograph will show sharp detail. *Depth of field* is the term for the zone within which a subject will look sharply defined. Beyond this zone, or field, subjects look "soft" or fuzzy. The optical principle involved makes the field—the distance from the nearest object in the

scene that will appear in focus to the object farthest away that will still be in focus and look "sharp"—*increase* as the *f*-stop (aperture, or lens opening) *decreases*. Thus, a small *f*-stop, say, between *f*/16 and *f*/32, will produce the greatest depth of field while a large opening, such as *f*/2 or *f*/1.4, will produce the least depth of field. (An easy memory device is this: Since the smaller the aperture, the higher the *f*-number, all you have to do is remember that large *f*-numbers mean large depth of field.)

Modern automatic lenses have an iris diaphragm that stays wide open until the moment the shutter is released. This is an advantage because you can focus and compose with a bright, clear view. To see what the final image will really look like, though, you must see the subject through the *taking* aperture, that is, with the diaphragm "stopped down" (closed) to the chosen *f*-stop. This is done with a depth-of-field *preview* button or lever on the camera. By pressing it, you can see whether the zone of sharpness is acceptable to you—whether you have the depth of field you want. If it is too shallow you will have to use a smaller *f*-stop. If the background looks too sharp, you can open up the lens's iris diaphragm until a larger *f*-stop puts the background enough out of focus (as was described in Chapter 2). Depth of field will be discussed further in Chapter 5 in connection with close-up photography.

Lenses

You will be able to create interesting photographs with maximum efficiency if you have the lens that is best for a specific application or situation.

The lens that comes with a camera is called "normal" because it covers an angle of view close to that seen by the human eye. On a 35 mm camera, this lens generally has a focal length of 50 mm to 55 mm. With 2¼ square format, the normal lens is about 80 mm.

Macro

The correct term for these lenses is *close-focusing*. For close-ups of flowers, foliage, seeds, and other small objccts, it is convenient to be able to come closer to the subject in order to produce a larger image. (Nikon calls these lenses "micro" because you can shoot from a *smaller distance* rather than "macro," which indicates a *larger image*.) Many of these macro lenses can focus from infinity up to half life size, and with a short extension tube between the lens and the camera you can make life-size photographs—a 1:1 image. This means that a flower 1½ inches wide will fill the whole frame on 35 mm film.

Using a longer-focal-length macro lens—say, 105 mm—lets you work from farther away. You will still get a large image on the film, but with less danger of overshadowing your subject. If you can have only *one* lens on your 35 mm camera, a macro, or close-focusing, lens would be a good choice.

A close-focusing zoom lens is especially useful in the field, where portability and versatility are very important. A 70–150 mm close-focusing zoom like the one shown at left allows the photographer to compose and frame his subjects with precision. The picture of *Allamanda* below was actually taken at the subject-to-lens distance shown in the picture above.

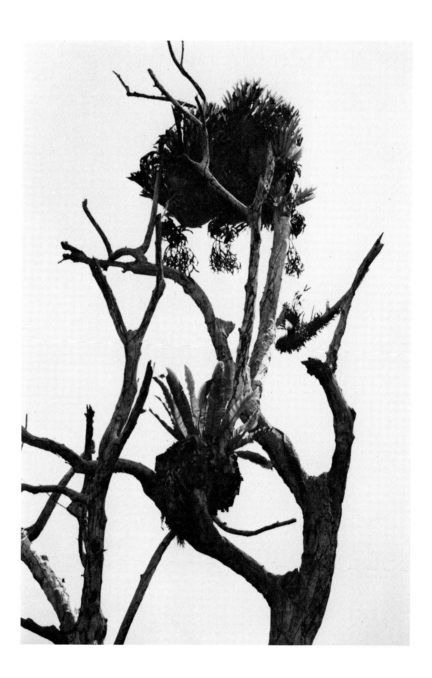

Long lenses will get you to places you cannot otherwise reach. A 200 mm zoom was used here to capture the dramatic silhouette of a dead tree with epiphytic ferns growing on its topmost branches. The shot was taken in Malaysia.

Long

For 35 mm cameras, a lens of 100 mm to 105 mm is a good choice for plant photographs outside, or for medium-sized plants indoors. The angle of view is narrower than that of a normal lens, so backgrounds can be smaller but still fill the frame behind a subject. Also, this focal length does not exaggerate what is closer to the camera, and so it produces a natural-looking perspective.

Wide-angle

Wide-angle lenses let you exaggerate perspective, and also capture a broad or tall subject even when you cannot move farther away. Outdoors, a lens between 35 mm and 28 mm in focal length is a versatile choice on 35 mm cameras. The extreme wide angles, from 20 mm down to the *fisheyes* of 8 mm or 6 mm, will produce dramatic perspectives but are of limited use in the usual sort of garden and flower photography.

Perspective-control

One specialized type of wide-angle lens permits adjustment in perspective by shifting the lens elements while the camera remains stationary. These PC lenses are useful in landscape and architectural photography. They serve as standard wide-angle lenses when the perspective controls are not shifted. They are expensive, but can be useful.

Supplementary optics

A limited range of telephoto and wide-angle effects are possible with cameras that do not allow interchange of lenses. Screw-in supplementary lenses can turn fixed lenses into long or wide or close-up lenses, but the results are rarely as sharp as those from interchangeable optics. (See Chapter 5 for more detailed information.)

Zoom

Lenses that have changeable focal lengths are popularly called *zoom* lenses. They originated with motion-picture technology. Now they are made for 35 mm cameras in wide, normal, and telephoto designs. Zoom lenses let one work faster when adapting to changes in subject size. Some modern zooms have a close-focusing (macro) feature that lets you capture subjects at almost life size. Most useful are those that zoom between 70 mm and 210 mm in focal length.

Before purchasing a zoom lens, be sure it will cover the range and the focusing distances you need. For landscape work, the close range may not be important; but if you wish to fill the frame with small subjects, the close-focusing distance and the potential magnification are of prime importance.

True zoom lenses hold focus throughout their range. If you focus at 4.6 m (15 ft) in the 200 mm position, then zoom in to the 100 mm focal length position, the focus should remain crisp. A variable-focal-length lens is similar, but you must refocus every time the focal length is changed. There are many different models of these lenses now, with new ones appearing rapidly; so it is wise to look at a variety before deciding on any.

It is also possible to get a higher magnification from close-focusing zooms by adding a tele-extender. Some lens makers offer tele-extenders designed specifically for certain of their lenses. Just be aware that tele-extenders require an exposure increase. For example, using a tele-extender with Kodachrome 25 to photograph wild flowers on a breezy overcast day is not practical if you need good depth of field and sharp subjects unless you use flash to increase the light level.

With a tele-extender, the close-focusing distance of a lens remains the same, but the image size is larger. A 105 mm lens that focuses to 76 cm (2½ ft) will still focus to 76 cm with a 2× extender, but the subject will *look* twice as big. Unfortunately, the depth of field is cut in half, too!

If budget is a major consideration, choose a versatile zoom lens that delivers the range and magnification you would use most often. Add greater flexibility by using matched tele-extenders.

Filter sizes

If you want to own several lenses, you may want to get them all with the same size front mount (filter size). If you select a zoom with a 55 mm screw-in front size, for instance, none of your 52 mm screw-in filters or other front-lens accessories will fit. Step-down adapter rings will adjust larger filters to smaller lenses; but smaller filters will not work on larger lenses.

Perspective

Changing lens focal length and/or camera position is a useful way to vary perspective, as was mentioned in discussing composition in Chapter 2.

For close-up photography, you will get the best (most "normal") results using lenses between 50 mm and 200 mm on a 35 mm camera. When wide-angle lenses are used very close to the subject, they create unnatural perspective. At the same time, they need to be held so close to the subject that

little room is left for attractive lighting. Outdoors, or wherever medium-to-distant views are taken, the situation is different.

The perspective-control lenses described earlier are unlike any others. Since the perspective control works both horizontally and vertically, you have freedom to vary the composition, even with stationary objects

The "how" of a picture can depend on the "why"; that is, what you want to show in a photograph can decide your camera position (point of view) and your lens. All the pictures on these and the following two pages were taken with a 35 mm camera mounted on a tripod 2 m (7 ft) from the hibiscus. Only the lenses were changed. In the first picture, a 50 mm "normal" lens was used. The hibiscus can be seen at center right. Then the photographer switched to a 55 mm close-focusing lens (center photo). Next, a 105 mm lens was used. A medium orange filter helped to isolate the orange-colored 'Fiesta' hibiscus from surrounding green foliage by increasing contrast: A colored filter will make objects of the same color appear in a photograph as a paler shade of gray than if the picture had been taken without a filter. Sunlight shining through the translucent glass panes of the plant house at the New York Botanical Garden provided diffuse illumination.

right in front of your camera. By adjusting the knob, a photo of tall trees can be made in limited space without the odd tilted-back look: The lens shifts position, instead of the camera.

Test your options

Learn what changing lenses can do for composition by making a series of photographs, such as the following:

1. Photograph in a garden, using a 50 mm lens on a 35 mm camera for "normal" angle of view and perspective. Include a flowering shrub or other attractive feature at one side of the frame. With the 50 mm lens focused at between roughly 3 m and 4.5 m (10 ft and 15 ft), the whole landscape will have a straightforward impression.

2. Change to a wide-angle lens, perhaps a 28 mm. Move *toward* the flowering shrub until it is the same size and position in your frame as it was with the 50 mm lens. You have now changed perspective, and your angle of view is wider. Does more show above and to the sides of the central area?

3. Now put on a long lens—a 105 mm, for example. Move *back* until the same shrub at the side of the frame occupies the same space as when shot with the other two lenses. You have now narrowed your angle of view. See how the perspective has become slightly compressed?

Camera and Lens

Making the Choice

The popular camera brands are well pictured and described in color folders offered by major manufacturers. Most camera stores have a supply of free descriptive literature you can study before doing personal research at the counter. Friends who own modern cameras are also good sources of information. Hold, focus, and shoot the cameras you are thinking of buying. Seeing how a model handles *for you* is important. Pick one that fits *your* hands best. Check controls, viewfinder (especially if you wear glasses), and weight of models in your preferred price range, then choose the model best suited to your photographic needs.

The common types of focusing screens supplied as original equipment on 35 mm SLRs include

- *microprisms*, with central areas that make the image snap together when in focus, shatter when out of focus;
- *split image*, where within a central circular area the subject divides when focus is out but comes together when focus is perfect (the system may not work when used with macro and telephoto lenses; so check it thoroughly);
- combinations of microprism or split-image systems with a *ground-glass* screen (here, if the split image gets dark you can still focus with the microprism or on the ground glass).

Consider buying the camera body with a lens other than the "normal"

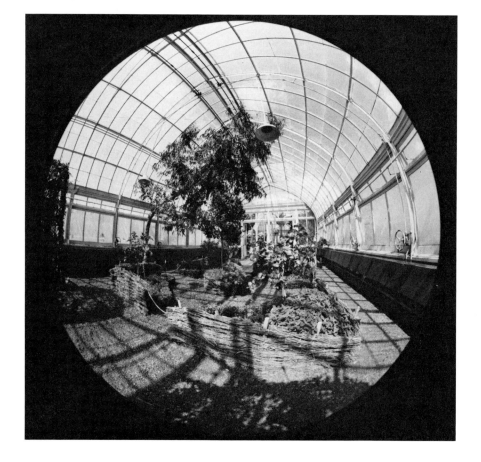

An 8 mm lens has a tremendous angle of view, which creates the "fisheye" effect seen at the left. This perspective distortion accentuates the curve in the tree and in the roof of the plant house, both of which had curving forms already. Although a fisheye is not a good choice for a documentary shot, it can be extremely effective when you want an unusual rendering. In the photographs here, as on the preceding two pages, the photographer maintained a distance of 2 m (7 ft) from the hibiscus at center, making only minor position adjustments for pleasing composition.

The view becomes much more conventional when lens length is increased from 8 mm to 20 mm (*above*). While a lens with a focal length of 20 mm is still considered a wide-angle optic, it does not distort vertical and horizontal lines nearly as much as the true fisheye. In the picture at right, the photographer used a perspective-control lens to avoid the distortion of the wide-angle lens (here, convergence of vertical structures). Whereas a 35 mm standard lens would show the door frames of the plant house as tilting slightly inward, the 35 mm perspective-control (PC) lens allows the photographer to adjust the lens until vertical lines are seen as parallel.

one offered with the camera. For example, if you are not going to photograph under low light conditions where a large maximum aperture ($f/1.2$ to $f/2$) might be useful, consider getting a 50 mm or 55 mm *macro* lens as your normal lens (some macro lenses only open up to $f/3.5$).

If you can afford two lenses for close-up work, a good combination would be a compact close-focusing zoom of, say, 70–150 mm for use in the field and a high-quality macro single-focal-length lens—anywhere from 55 mm to 105 mm—for close-up work at home.

As with all major equipment, you should hold the item and preferably test it before purchase. Remember that friends, camera club members, and full-service photographic dealers are usually happy to let a responsible enthusiast examine their equipment.

Read the instructions

Photographers involved with a constantly changing array of equipment have a joke remedy for breakdowns: "When all else fails, read the instructions."

You will save money, time, and frustration if you go through the instructions step by step, with the equipment in front of you, until you understand how it works. Then, after practicing with all the controls, expose a test roll, using the same kind of film you plan to use later for plant photography. This first roll will show you quickly whether your camera and you are working correctly.

If your first roll shows good exposure, easy advance, and satisfactory sharpness, chances are that the camera and lens are in perfect condition. If anything seems odd or is obviously not functioning correctly, pack the camera in its original box for return to the dealer. (By the way, it is wise not to send in registration cards until *after* your first test roll is ready. Many dealers quickly replace defective equipment if you return it with all original documents and packing.)

Recommendations for Choosing Cameras

If you are new to photography, or have decided to get an advanced-design camera, look for one that offers these features:

1. Single-lens-reflex design
2. Behind-the-lens metering
3. Manually adjustable exposure option ("override")
4. Automatic lens diaphragm for full-aperture metering
5. Compatibility with electronic flash
6. Tripod socket
7. Depth-of-field preview.

The above features are found in many different camera formats. For the average photographer who wants a versatile camera that will give good results for plant photography *and* other popular subjects—such as travel, documentary, and family situations—here are some additional recommendations:

8. 35 millimeter format
9. Interchangeable lens capability
10. Well-known international brand, with convenient factory-authorized servicing in your area
11. Size and weight to fit your hands.

The full beauty of a 'Gigantic Star' daffodil was captured in close-up by using a 55 mm macro lens on a 35 mm SLR camera and looking up at it from ground level. A small reflector redirected some of the strong sun into the flower's cup and top petals. Careful choice of camera position made the dark tree in the background frame the subject exactly.

4

Films: Color
and Black-and-White

Choosing film is just as important as selecting the most appropriate equipment and background for plant photography.

Films have an international rating based on their *sensitivity* to light. Currently we use an ASA number (standing for American Standards Association, now called American National Standards Institute). Soon the designation is changing to an ISO number (International Standards Organization). The ISO numbers are the same as ASA numbers, but rather than seeing "ASA 25" on Kodachrome 25 you will see "ISO 25/15° " The second number refers to the DIN (Deutsche Industrie Norm) designation used in many European countries. No confusion will result if you remember always to check the film container. During the transition period, you will see the film speed also written this way: ASA 25/15 DIN.

A film that is too sensitive to light will make depth-of-field control difficult, while a film that is not sensitive enough complicates photography in dim light or where you want great depth of field. A fast slide film, such as Ektachrome 160, needs less intense light; so subjects under lamps will

stay cooler. Flowers can wilt under hot incandescent lights. Even blossoms still on the plant may wilt when kept under hot lights for only a few minutes.

Color Films

In color, the film *type* and *manufacturer* will influence color rendition because each brand of film renders colors in slightly different ways. There are six basic types of color film: color-negative (print) film and slide film for use with lamps, print film and slide film for use with daylight, film for use with studio lights. (*Slides* are transparent positives, whereas *color negative*, or *print film*, gives a negative that must be printed before the image can really be seen.) The sixth type is for instant prints.

Ektachrome films favor blues. This makes Ektachrome 64 a favorite for landscapes because the sky will appear deeper blue. Kodachrome is famous for "true" reds. Fujichrome delivers a softer, more pastel impression, Agfachrome enriches browns and is preferred by some photographers for tree-bark studies. My personal favorite for plant and flower portraits is Kodachrome 25 for transparent positives (slides), Kodacolor II (ASA 100/21 DIN) for a negative from which color prints are made. Indoors, under incandescent light, one can use Kodachrome 40 for slides, Kodacolor II for prints if one adds a blue No. 80A filter on the lens or in front of the light source.

For most plant photographers using daylight or electronic flash, the widely available Kodacolor II is the best choice when prints are desired. If you plan on doing photography with incandescent ("tungsten") lights and slow exposures, however, and use roll-film, Vericolor II Professional Type L (for "long exposure time") is a good choice. Type L is not available in 35 mm format. The best choice for 35 mm users wanting long exposures under tungsten lights is Kodachrome 40 because good prints can be made from the resulting slides.

A general rule is to select the lowest ASA rating—the "slowest" film speed—because the least sensitive ("slowest") films are most likely to render colors true to life. Therefore, when there is adequate light (daylight or electronic flash), or the freedom to take long exposures without having the subject move, Kodachrome 25 (ASA 25/15 DIN) would be a fine choice. In dim light where slow exposures are not possible, or at a flower show where tripods cannot be used, Ektachrome 200 (ASA 200/24 DIN), Ektachrome 400, or Fujichrome 400 (ASA 400/27 DIN) for slides, and Kodacolor 400 or Fujicolor F-II 400 (ASA 400/27 DIN) for prints, would be better choices.

It is also useful to know that slides can be made from color negatives by professional color labs, and excellent color prints can be made from slides.

Color temperature

Common light sources, including daylight, range from "warm" to "cool." Different types of color film are balanced for use without correction filters within different narrow ranges of color temperatures. Some color temperatures you will encounter are listed here, from blue-toned ("cool") to orange-toned ("warm").

Light from blue sky	9000 to 20,000 Kelvin
Electronic flash	5500 to 6100 K
Blue flashbulbs	5500 K
Direct sunlight, midday	5000 K
Photoflood lamps	3400 K
Tungsten-halogen studio lights	3200 K
Household incandescent ("room light") lamps	2800 to 2900 K
Candle flames	1900 K

For example, if you are using a tungsten lamp labeled as 3200 K, the film for slides should be Ektachrome 160 or Ektachrome 50 Professional, since these are balanced for 3200 K light. If you use 3400 K lights you will get slightly cool results. (The higher the Kelvin temperature, the bluer the light is.) The reverse occurs when using Kodachrome 40 with 3200 K lights. Some photographers like the warming effect of using a film balanced for 3400 K under the warmer-colored 3200 K lights. If you use tungsten lamps for plant photography, do your own experiments: Use transparency film, then look at the slides side by side on a light box to see which color balance you like best. Read the data sheet packed with the film to find out the manufacturer's recommendations. (See *Filters* in Chapter 5.)

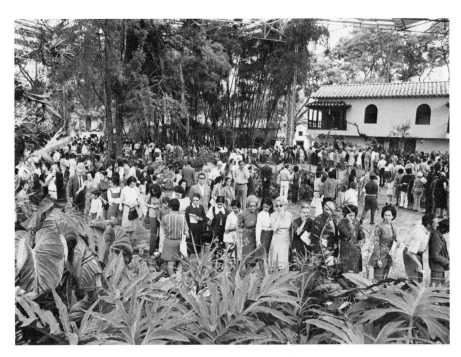

A highly sensitive, or "fast," black-and-white film like Tri-X or HP5 is the best choice for documentary photographs like this. The occasion was an orchid show in Medellin, Colombia.

Usefulness of flash

A few blue flowers may look too pink if photographed in direct sun (ageratum is a prime example). This is because of something called *anomalous reflectance*, caused by high reflectance at the infrared end of the spectrum. Color films are more sensitive to this than the human eye is. The irregular (anomalous) reflectance can be minimized by using electronic flash. These rare problem flowers look much less pink—truer blue—when lighted with flash or diffused sunlight.

If you use a flash unit, though, consider how powerful it is and how much depth of field you need, since these factors should influence the choice of film for each application.

Black-and-White Films

Images are formed on photographic films of most types by the action of light on silver halide crystals in the emulsion, or coating, on the film. After chemical development, the silver remains on the film in the form of clumped or scattered particles. For photographs in black and white, the structure of these clumps of "grains" becomes important when enlargements are to be made. The whole negative of an image made on 35 mm film is about 24 × 36 mm (1 × 1½ in.), and enlarging it past 20 × 25 cm (8 × 10 in.) will reveal a granular pattern that may or may not be acceptable, depending on personal taste. High-speed film such as one rated at ASA 400/27 DIN is useful for field work, but if a small section of

that small negative has to be enlarged the grain may become noticeable, especially in light areas like sky or white flowers.

Slow films have finer grain and therefore can be enlarged more than fast films before the grain becomes obvious to the eye. When there is lots of light, as in a studio with electronic flash or quartz lights, Ilford Pan-F (ASA 50/18 DIN) or Kodak Panatomic-X (ASA 32/16 DIN) are good choices. These black-and-white films have extremely fine grain and very high resolving power (ability to hold fine detail). They allow the 35 mm negative to be enlarged greatly and still show fine detail and a smooth grain pattern.

In between the extremes of the ASA 400-speed and the ASA 32-speed films are medium-speed ones such as Agfapan 100 (ASA 100/21 DIN), Ilford FP4, and Kodak Plus-X (the last two are ASA 125/22 DIN) For formats 110, 126, 120, 127, and 620 cameras, Kodak has Verichrome Pan (ASA 125/22 DIN). Medium-speed films are good choices for on-site photography in moderate-to-bright light. Having a medium speed, or rating, gives you freedom to vary the depth of field by shooting at wider lens openings, something difficult to do with ASA 400/27 DIN films in bright light.

Film Choice Depends on Purpose

The final use of your photographs will have something to do with the film you select.

For publication, lectures, garden society slide programs, and showing to large groups, you will need *transparencies* (slides) in color. Select a film that produces slides directly, such as Fujichrome or Kodachrome. Excellent prints can be made directly from slides. Custom labs make a negative from the slide, then produce prints with full control over final color balance, cropping, and similar variations.

Use a *color negative* film if you want mainly for prints for albums or decorations, to show friends, mail with letters, create a display, or make greeting cards. You can ask the lab to make small prints or a *contact proof sheet*. Enlargements are made afterward from any frames you select. Color labs can also make good-quality color slides from the color negatives.

Black-and-white prints can be made directly from color negatives. For best results prints are made on Panalure, rather than on the usual black-and-white enlarging papers.

Black-and-white or color?

Most of us want color photographs to capture the beauty in plants and flowers. For publication, however, some magazines and newspapers must have black and white. Many plant society magazines, for instance, cannot afford to use more than a few pages in color; so they have a constant need for high-quality black-and-white prints. Color slides can be copied to black-and-white negative film, then printed, or prints can be made from color negatives; but quality is better if the original subject is photographed with an appropriate black-and-white film.

Artistic considerations, too, turn some plant photographers toward black and white. For example, a series

of tree silhouettes, bark textures, seed pods, or how-to-do pictures is often more powerful in black and white. Even for home decoration, some people prefer black-and-white enlargements.

Instant Prints

Instant-print films such as the famous Polaroid Land film and more recent Kodak Instant Print Film give you the pleasure and convenience of seeing your photographic creation immediately. If anything has gone wrong you can see what happened and quickly take another photograph.

Instant prints are useful when one needs a quick print to send in a letter or otherwise communicate visually without the wait for lab processing. Professionals frequently use instant-print films to evaluate lighting effects, depth of field, composition, and other important elements of their work. When all aspects of the photograph are satisfactory, the photographer makes the final photograph on color transparency, negative, or black-and-white negative film. (See Chapter 3 for information about cameras that use instant-print films.)

Instant prints are popular with amateur photographers who seldom need enlargements, duplicates, or enlarged prints for publication. They are not useful when one needs slides for publication or projection although both Polaroid and Kodak labs do offer reasonably priced enlargements or duplicates from prints made with their films.

Some cameras accept Polaroid positive/negative film Type 665 (ASA 75), from which one gets an excellent quality print *and* a negative with each exposure. The negative will give fine-grain enlargements with excellent detail. The print, produced in about 30 seconds after in-camera exposure, is also top quality. There is one drawback: This film must be put into a solution of sodium sulfite within a few minutes after development, although water can be used in an emergency. Still, this means carrying around a bucket of solution—either chemicals or water; so the positive/negative Polaroid Land film is really only practical at home or in the studio. The results from this unusual material are good.

An instant-print black-and-white transparency film is also made by Polaroid. It is especially useful for scientific plant photography, and teachers appreciate being able to get instant transparencies for use on overhead projectors.

Full details about Polaroid Land films can be had by writing for free booklets to the Polaroid Corporation, Cambridge, MA 02139.

Film Speeds Can Be Changed

Some color films, and most black-and-white ones, can be used at a higher rating, then push-processed. Eastman Kodak labs offer, for a small extra charge, Extra Special Processing (ESP), which lets you double the film speed—Ektachrome 160 film can

Films: Color and Black-and-White

A slow film is a poor choice for subjects that are blowing in the wind—unless you intend to use blur to create a feeling of motion. Here a 'Red Missile' pepper was photographed at 1/15 sec. on Panatomic-X (ASA 32/16 DIN). The lens was a 55 mm macro at *f*/11, with a green filter.

be shot at ASA 320, Ektachrome 200 film at ASA 400, and Ektachrome 400 film at ASA 800. Naturally, the *whole roll* must be exposed at the same rating, and the lab must be told that the film has been exposed at a higher ASA than normal. You will notice a slight gain in contrast, and colors will not be as true; so do not push film if you can take the photographs at the recommended film speed.

Rescuing mistakes

"Watch your ASA" is not a rude remark! Every time you load a roll of film, check that the camera's meter is set at the correct sensitivity rating— ISO, DIN, or ASA. Usually you will want to use a film at the manufacturer's recommended speed. Avoid errors by checking the numbers on the film cassette or roll as you put it in the camera, then be sure the meter (and any hand-held meter you may be using) is set appropriately.

If you do make a mistake, there may be a way to save the photographs. As mentioned before, some films can be processed at other than standard ratings. For example, Ektachrome 200 film exposed at ratings of ASA 100 or ASA 300 can be processed by a custom lab, where each roll is processed individually.

Black-and-white films have so much "latitude" that a one-stop error in exposure may go unnoticed. Films rated at ISO speeds of ASA 400/27 DIN that have been exposed at from ASA 200 up to ASA 800, or Plus-X film (ASA 125/22 DIN) shot at from ASA 80 up to ASA 200, will still produce printable negatives when processed for the normal rating. Color films do not have the same latitude. The most difficult is Kodachrome. If you accidentally expose Kodachrome 25 at, say, ASA 100/21 DIN instead of its normal ASA 25/15 DIN, it is better to take the photographs again.

The same ornamental pepper was photographed again, this time with a fast film (ASA 400/27 DIN) but using the same lens opening (*f*/11) and filter (green). The result is perfectly "sharp" because the fast shutter speed "stopped" the motion of the plant despite the wind.

Color shifts at "wrong" speeds

Color film sold for general use, such as Kodachromes, Ektachromes, and Kodacolors, yield true colors when exposed at shutter speeds between 1/1000 sec. and about 1/8 sec. At faster or slower shutter speeds the film reacts differently to light, and color values may shift. The resulting change in sensitivity and color balance is called *reciprocity failure*. You need not be concerned with this unless you use the film at far beyond its recommended range of exposure times.

Always follow the suggestions in the folder packaged with the film. Films are frequently changed slightly by the manufacturer, usually for im-proved rendition of color and better stability, and the recommendations for precise exposure, filtering, etc., may change, too. For example, Kodak recommends a one-stop exposure increase and a color-compensating filter (CC10M—light magenta) when Kodachrome 40 is exposed for as long as one second. However, exposures longer than 1/10 sec. are generally not needed except when you wish to have màximum depth of field and therefore must use a very small lens opening and a correspondingly long exposure.

Conclusion

When the correct rating is set in built-in or hand-held meters, you will get the best results. If you choose to use nonstandard ratings, especially higher ones, be prepared for increased granularity and, in color, for color shifts.

Films: Color and Black-and-White

In some situations, black-and-white film is more effective than color. Here, a dramatic composition results when the East African baobab tree (*Adansonia digitata*) is photographed against a cloudy-bright late afternoon sky.

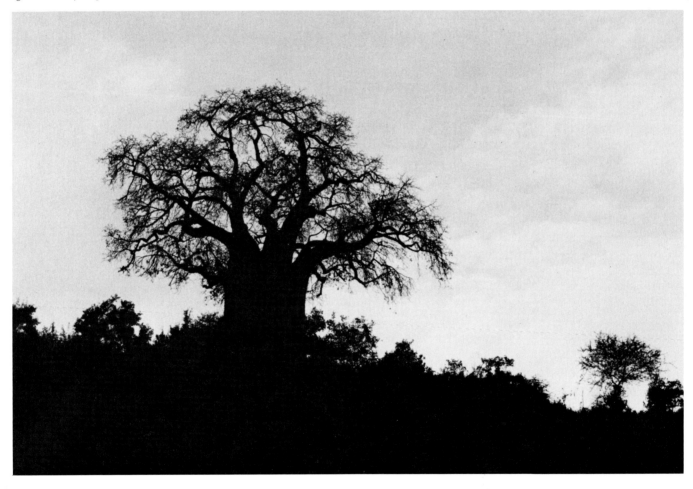

Some bean seeds were planted in a glass-fronted box for study purposes. Here the seedlings are illuminated by sun coming through an overhead tent of white tracing paper. Their vigor is emphasized by the low camera angle. Photograph by Thomas L. Gettings.

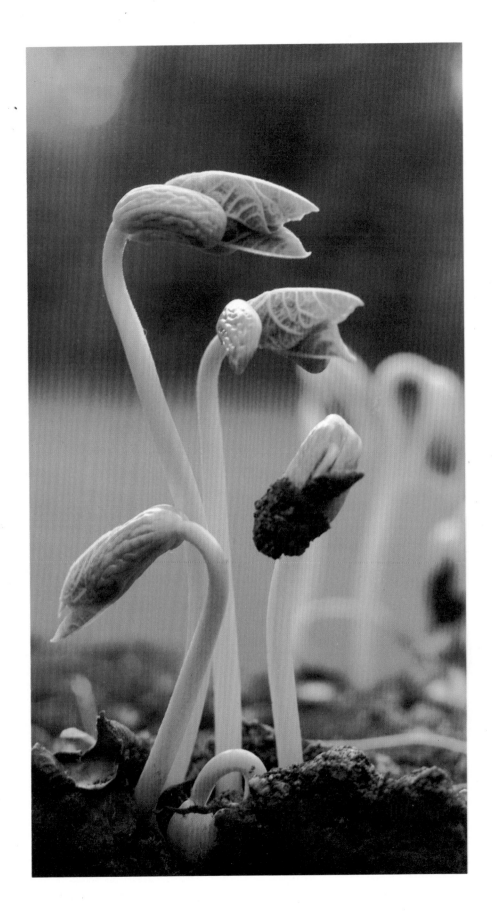

Above: **Late afternoon sun intensifies the reddish-gold color in a dwarf Japanese maple (*Acer palmatum dissectum*); the photographer chose an angle that puts it in contrast with dark shrubs. Careful composition can capture the essence of a landscape even though only a small portion of it is shown.**

Opposite page: **A study in greens is brought to life by inclusion of the red bridge and the children scampering through the Huntington Japanese Garden in San Marino, California. Landscape photographs are often more interesting when they include a color accent—especially a contrasting or a complementary one—and people.**

These two pages show how creative composition captures important garden features, eliminates distractions, and provides a feeling of depth.

Opposite page: A spring garden in New England invites one to explore further, leading the eye from a subdued foreground into brighter areas and on toward the white flowering dogwood.

Right: Blossoms on the tree peony Black Sea are tightly framed, with just enough foliage showing to reveal the shrub's personality. The picture was made from a high angle to show the bright yellow anthers and so provide a dramatic contrast and center of interest.

Below: Lilies frame a summer perennial garden. All is made more beautiful by backlighting from early afternoon sun (note shortness of shadows).

A well-chosen viewpoint and keen observation of the angle of light contribute to expressiveness in photographs, especially of subjects in nature.

Left: The photographer is using a high angle, looking down at the marigolds in order to fill his frame with their flowers and foliage.

Below: Here the camera position lets the fence covered with roses be seen on the diagonal, giving depth and balance to the composition. Afternoon sun highlights the flowers and neat lawn, while in the shadows there is only enough detail to identify this as a home setting. At a different time of day, the building might have distracted from the roses.

Right: An extremely low angle puts *Colchicum* Disraeli against sky and distant oak trees, which are attractively blurred by the limited depth of field of a 55 mm macro lens on a 35 mm SLR camera. Texture and color of the petals are emphasized by three-quarter backlighting from the low afternoon sun.

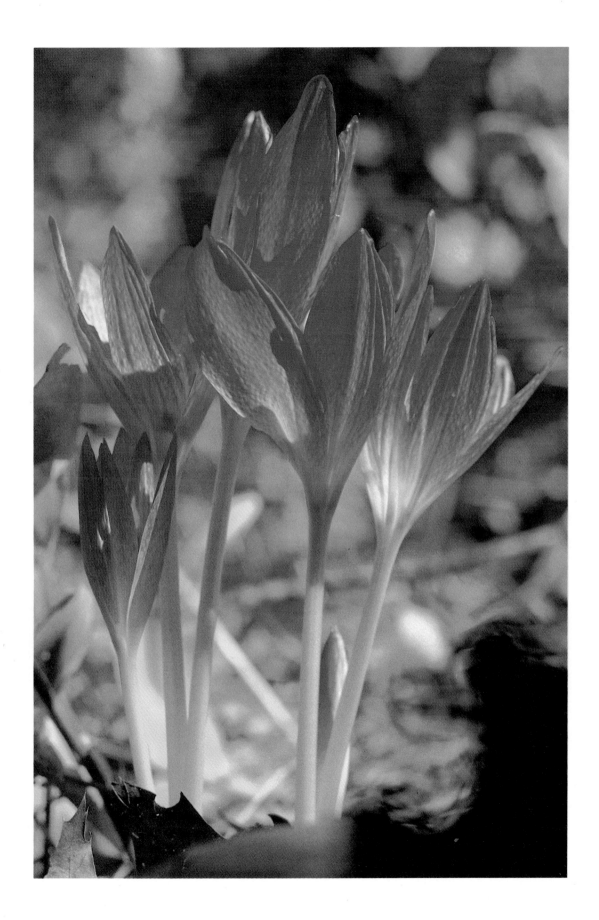

By almost filling the frame with a single passion flower, the photographer not only shows the blossom's intricate structure but also evokes the drama we associate with its name. Overcast light outdoors enhances the blue tones in the flower's coloration. Photograph by Gary F. Leatham.

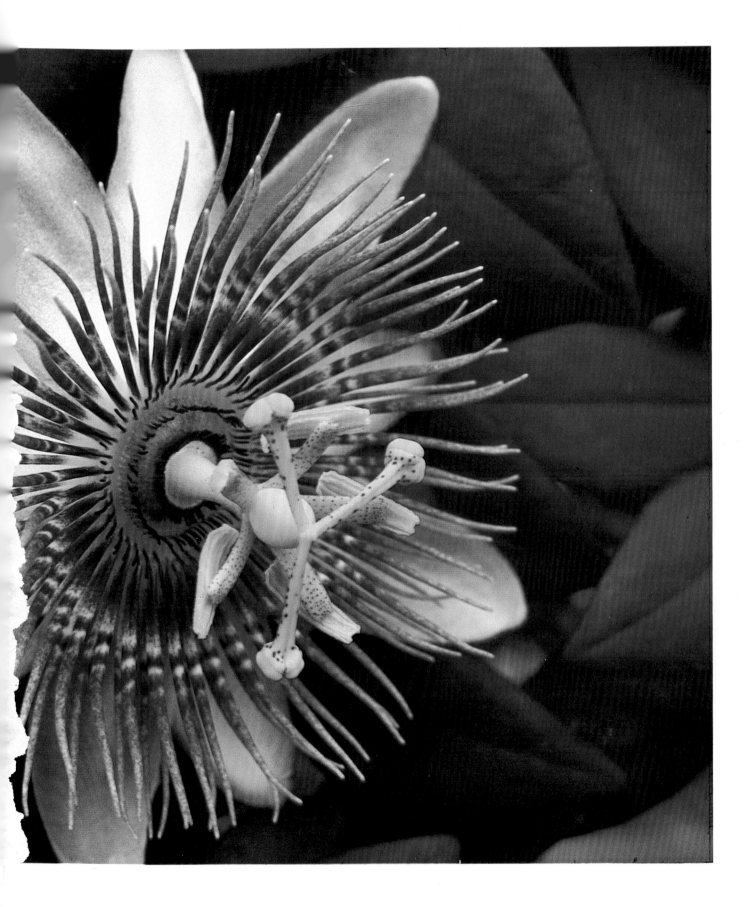

Orchid *Anguloa clowesii* has a complex inner structure only seen from above. Electronic flash diffused with Mylar provides main light from above right; a silver reflector at the left bounces light back to fill in shadowed areas.

Electronic flash bounced from an umbrella gives soft illumination for this delicate composition of miniature succulents. Thimble container gives away the size. Photograph by Margaret Smyser.

The size of the gardener's hands shows how tiny this terrarium is, while their action teaches us something about cleaning the glass bowl. Lighting for this study was sunlight diffused through a greenhouse roof. Photograph by Margaret Smyser.

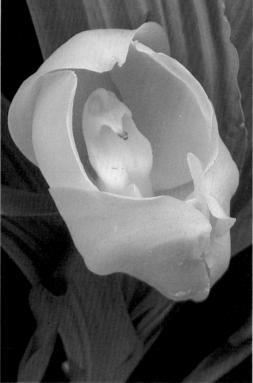

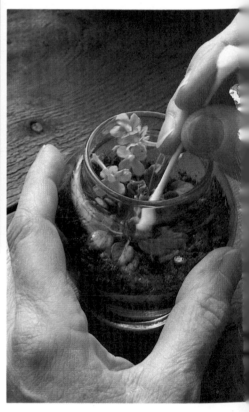

Placing *Brassavola* David Sander "Talisman Cove" against a black background emphasizes this orchid's delicate fringe. Pencil-shaped foliage and glimpses of other blooms can be included, thanks to the precise viewing possible with a single-lens reflex camera.

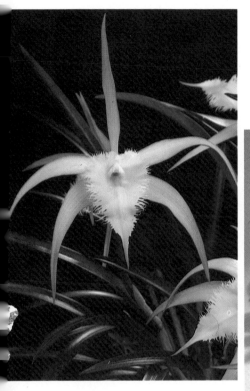

Even plain green foliage plants become interesting in this skillfully composed study of green leaves on yellow seamless paper. Strong electronic flash from behind, with a weaker fill from the left, changes saturation, or richness of color, in the background paper. Shadows caused by the backlight are an important part of this composition. Photograph by Christie C. Tito.

Laelia gouldiana flowers shine dramatically against the dark background when given direct front lighting with a portable electronic flash from 51 cm (20 in.) away. An aperture of *f*/11 assures sharp details, while precise exposure makes for good color.

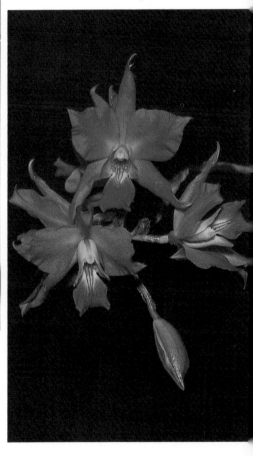

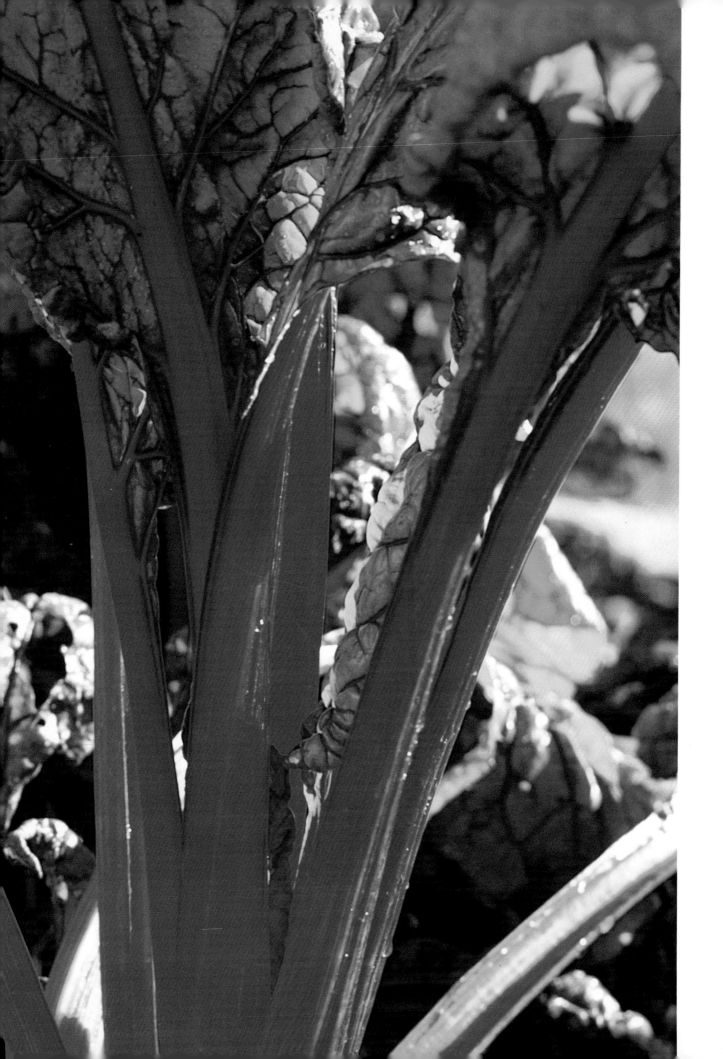

Opposite page: Ruby chard is food for the soul when captured on Kodachrome in a backlit close view. The low angle of the sun's rays in early morning and late afternoon enhances views of plant structure. Here, the afternoon sun also slightly emphasizes the redness of the stems.

Below: A Chinese lacquer tray with golden-orange tones supports this Oriental persimmon. Old Chinese coins echo the fruit's calyx with their hue and shape and help balance the composition. Light is from studio electronic flash aimed through Mylar diffusion material.

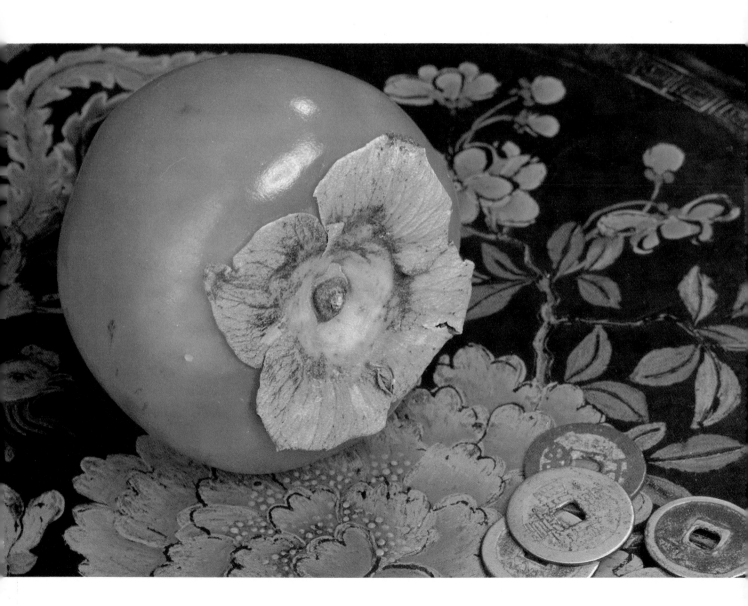

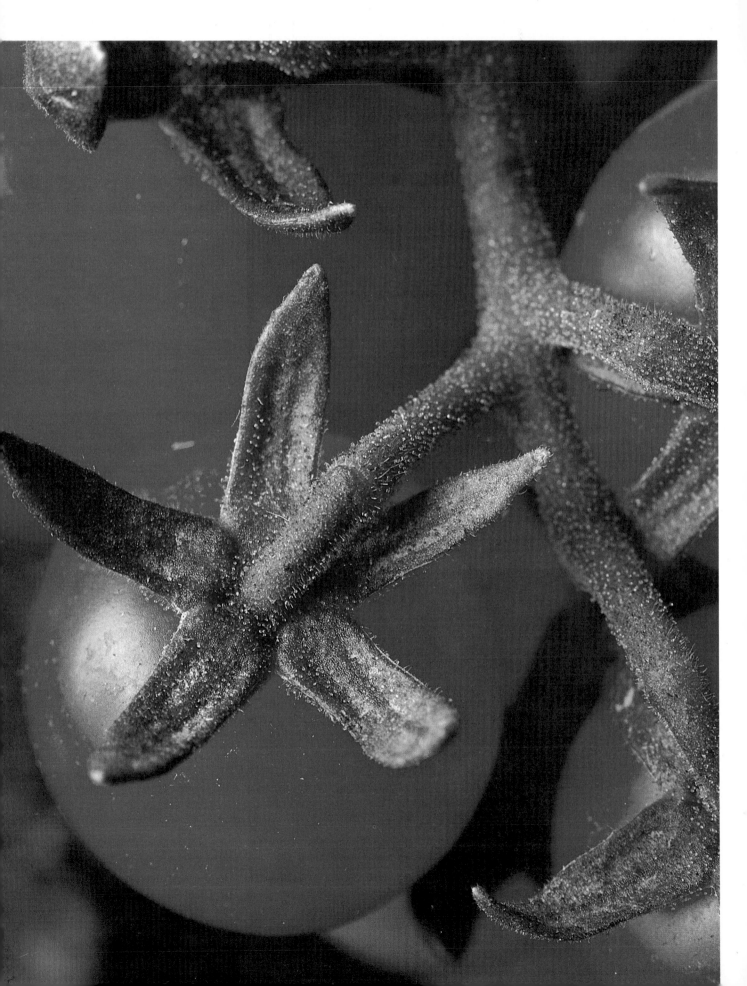

Right: Hot peppers look all the more fiery when photographed under diffused sunlight because colors become fully saturated; the stems have become slightly blue, however. Cloudy overcast and shade both have this effect. Photograph by Thomas L. Gettings.

Opposite page: A tomato plant was photographed in the garden. A large lens opening, giving shallow depth of field, puts attention on an interesting aspect of the subject. Direct sun is a fitting light for plants that thrive in warm, sunny weather. Photograph by Christie C. Tito.

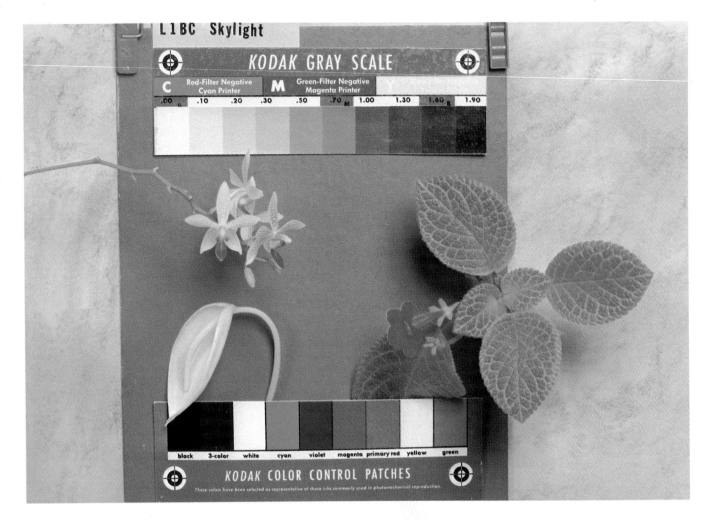

This composition of three subjects, two test scales, and a neutral-gray card against a homemade pastel background was created to show the effects of filters with black-and-white film: Compare this color view with the illustrations on page 65 to see how colored filters change the gray-tone rendition of each subject on black-and-white film. The flowers at upper left are *Phalaenopsis* Little Sister, at lower left *Anthurium*, at right center *Episcia* Moss Agate. The neutral test card, available from camera stores, is used for precise meter readings. The small test patches are further aids in determining the effects of filters and exposures.

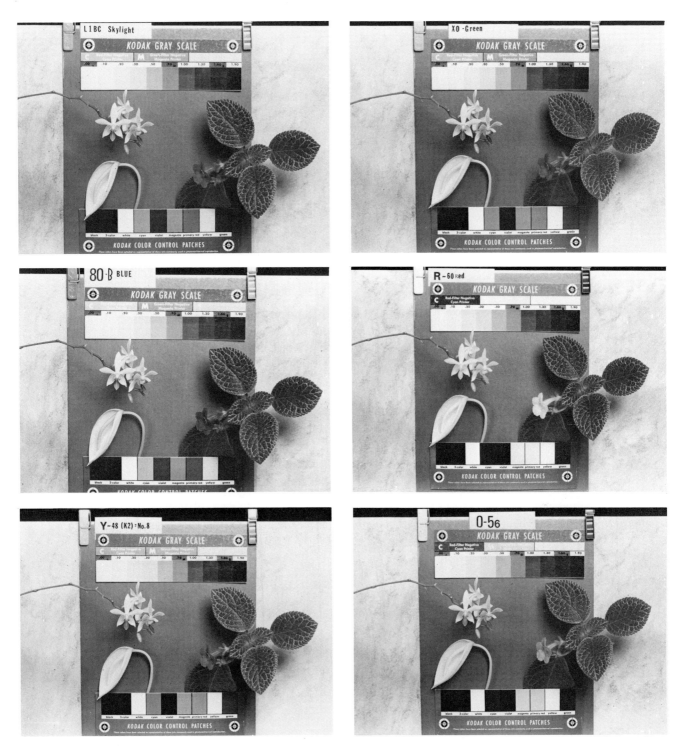

The pictures above show how you can use filters to influence the way colors will look in black-and-white photographs. Compare these with the color page opposite. Study the original colors; then follow one hue through each black-and-white frame to see how the different filters change—or do not change—its tonality of gray in relation to the other tones in the test scene. For example, see what happens to the cyan (blue-green) Color Control Patch under the influence of the green, the red, and the orange filters. The filter colors shown here are almost clear (the skylight filter improves the rendition of sky and cuts excess blue in the atmosphere but has almost no effect on other colors), light green, very light blue, red, medium yellow, and medium orange. (Disregard the numbers at the top of each frame: These are color codes used by a variety of filter makers.) All the black-and-white photographs were made on Panatomic-X film (ASA 32/16 DIN). Chapter 5, which follows, discusses filters and other lens accessories.

Depth of field was limited for this photograph so that a single 'Janie' marigold flower would stand out from the background. With a smaller f-stop, the whole group of flowers would have been sharp and the photograph would have been confusing.

5

Filters and Accessories

Even with an excellent single-lens reflex and suitable lens or lenses, a few filters can help you get superior quality in garden photography. I keep a skylight filter on my lenses all the time, both to protect the expensive lens and to eliminate excessive blue in outdoor color shots. Some photographers prefer an ultraviolet (UV) filter. More about filters later.

Important Accessories

Every lens should have a lens shade and a cap. The *shade* keeps light from hitting the glass directly, which could make photographs looked washed out or show *flare* and unwanted streaks of light. It can also shield the lens from rain and other hazards. The *cap* offers protection from scratches, dust, and blows.

Another small but useful accessory is a *wide release button*. This extends the height and width of the shutter release, permitting a softer touch and reducing camera shake at exposure time.

Tripod

Tripods are necessary for slow exposures and for precise composition. Even when you are using electronic flash and so need not be concerned with camera shake, a tripod will help you compose perfectly. Often you will want to take several frames of an important subject, "bracketing" the exposures slightly. *Bracketing* is the technique of exposing a series of frames, giving slightly more, then slightly less, exposure to each one. A tripod keeps the composition just as you wish from exposure to exposure.

Use a solid tripod whenever possible. Inexpensive, poorly made tripods are frustrating to use and may

Filters and Accessories

This outdoor arrangement for photographing an orchid seedling growing in coconut fiber uses a plain card for a background, a reflector at right on a tripod, and a white card seen at left, for additional bounce-light into the coconut shell. A tripod allows precise composition and a steady support for slow shutter speeds. A cloudy-bright day is best for such a shot because the shadows are soft and there is no harsh contrast.

not even hold your camera steady enough for slow exposures. Big studio tripods are the other extreme, too heavy even for at-home use and not necessary for compact cameras. In between are many well-designed tripods with various features, some especially useful in plant photography. For example, be sure your tripod can tilt to let you take vertical photographs. (Of course, this is not necessary with square-format cameras like the 2¼'s.) If you want to photograph small flowers in the garden, it is an advantage to have a tripod that goes very low. Some even have a reverse position.

A quick-release feature is useful if you switch from one camera to another frequently. One of my tripods has a removable hex plate in the center. Each camera body can be equipped with this sturdy plate; then, by turning a single knob on the tripod head one camera can be quickly removed and the other fastened in place. The hex plate has inlays of hard pebbled rubber, so that the camera holds firm even in the vertical position with a long lens.

Another useful device for composing at odd angles or on a small travel tripod is a ball-and-socket joint. When well made, such joints move smoothly in all directions, then tighten firmly with a large wing nut or screw. But be wary of small ball joints that are too weak for any but very small cameras. The ball-and-socket attachment can be screwed on top of a regular tripod head or can replace the tripod head.

This is the orchid seedling photographed with setup shown above. It is a *Cattleya* hybrid and has been growing in the plastic-mesh basket of Husky-Fiber for five months. The coconut shell with holes drilled in it will make a good pot for orchids. Notice how the bounce "fill" light makes details visible even in shadow.

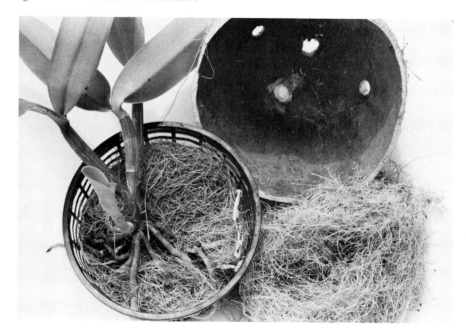

Tripods that will receive heavy use should have a minimum of knobs, screws, gears, etc. A lightweight tripod is handy for long-distance travel, but it may be a problem when you must use slow shutter speeds in windy areas, because it will wobble.

Each of the major manufacturers has several different types in their line. Visit a large photographic-supply store, look in the photography magazines, and study your friends' equipment before making a final selection. There are many reliable brands.

Cable release

A cable release is the most efficient way to avoid camera shake when releasing the camera shutter at exposures slower than 1/30 sec. The cable screws into the shutter release. When you press the plunger on the end of the cable, the shutter is released with a force much less likely to cause camera movement than when your finger triggers it. A good cable release costs only a few dollars and is small enough to be carried in a camera bag. Slow exposures made by means of a cable release when the camera is on a sturdy tripod are likely to be perfectly sharp—so long as the subject does not move.

Filters

Besides the skylight and UV filters already mentioned, there are some filters useful with black-and-white film, others for color film, and a few suitable for any sort of film.

For all films

Every plant photographer should have a *polarizing filter* to darken the sky and reduce certain surface reflections that can hide true colors. The polarizing filters will require between one and three stops more exposure; but behind-the-lens meters measure the light after it has passed through the filter, so no figuring is necessary. If you use a hand meter, allow the additional exposure recommended by the filter manufacturer and stated in terms of a *filter factor* (see below).

The polarizer is the only filter that will darken blue skies on color film without tinting the whole photograph. Outdoors in full sun the polarizing filter will remove most of the reflection from shiny foliage, water, and many flowers, thus giving better saturation on color films and improving visibility of details on black-and-white ones. It does not remove all glare from metallic surfaces, though.

With a single-lens reflex, you will see directly in your viewfinder what the filter is doing. Turn the polarizer

in its rotating mount until it is positioned for the amount of reflection control you want. The filter has its greatest effect when the sun is at an angle of about 45 degrees and the camera is at a 30-degree angle to the reflective surface; but at any time of day it is worth looking through the filter as you turn it, slowly, to see how it can improve the photograph.

At times there may be too much light for the exposure you wish to use or for the camera/lens combination to accept. In these situations a plain gray *neutral-density filter* will hold back some of the light, yet not have any other effect on either color or black-and-white rendition.

You will seldom need a neutral-density filter if you choose films according to the light available and the effect you want. However, if you have to use fast film under very bright conditions, or if you want to use shallow

Filters and Accessories

depth of field and there is too much light to shoot at $f/2.8$ or other wide aperture, consider one of these filters. They cut down one or two stops' worth of light without altering color values.

Some filters designed for use with color film, such as the blue No. 80B and the salmon-colored No. 85, can be used with black-and-white film to lighten their own colors (as explained below). A blue flower photographed through the blue No. 80B will be rendered in a lighter shade of gray than if photographed without a filter.

For black-and-white films

A general rule to remember for black-and-white photography is that a filter will *lighten subjects of its own color.*

For example, a green filter will make green foliage look a lighter shade of gray, in relation to the grays representing other hues, in the black-to-white range of the final print. A deep red flower, such as a dark geranium, usually requires an orange or red filter if you want detail to show in the petals: The filter makes the red register as a lot less dark, and so the details can be seen more clearly. To increase contrast between foliage and red flowers, use a green filter: This

will make green foliage look brighter, and so the red flowers will seem darker.

Filter "Factors"

Some filters require additional exposure because they hold back some light. The amount of this increase is called the *filter factor.* Automatic cameras and TTL exposure meters will make the adjustment by themselves. For rangefinder cameras and hand-held meters, increase the exposure reading by the filter factor to find the

A polarizing filter was used to cut most of the reflection from these flasks holding *Phalaenopsis* orchid seedlings. Enough reflection was left to show that the surface was glass; less would have looked unnatural.

70

With a green filter, this red miniature rose looks dark but the foliage has detail. Since some new rose leaves have a reddish coloring, they will not look as light gray as older leaves, which are pure green.

A red filter lightens this red miniature rose flower, but the leaves did not get too dark because they also have a red overtone.

correct exposure setting. Read carefully the enclosure that comes with the filter: The factor may be different under *different sources* of light.

Filter selection

Choice of a filter will depend upon the final effect wanted. The best approach for beginners is to photograph the same subject through yellow, green, orange, and red filters to learn what the filters do. You can then choose the ones you want for future work with a fairly exact idea of their effects. Turn to the color section of this book and study the color photograph of the filter test subjects; compare the colors with the grays in the black-and-white series made through various filters.

Filters for black-and-white film have been coded by a variety of systems ever since photography began.

Filters and Accessories

Color	Factor	Open lens by
Light Yellow	1.5	⅔ stop
Medium Yellow	2	1 stop
Deep Yellow	2.5	1⅓ stop
Orange	3	1⅔ stop
Light Red	6	2⅔ stop
Medium Red	8	3 stops
Dark Red	16	4 stops
Light Green	2	1 stop
Medium Green	5	2⅓ stops
Blue	6	2⅔ stops
Gray (Polarizer)	2.5	1⅓ stop

It is often easier to get what you want at the camera store by referring to colors rather than to codes. A few useful filter colors are listed below by their standard names and approximate filter factors (not all manufacturers make all the colors, and factors vary slightly among the different brands).

Major filter makers pack information with their filters, giving the factor under various conditions. Some companies even offer free color folders showing what the filters can do—ask at your camera store.

Color-conversion filters

Color films are designed to give true color rendition when exposed with a specific color of light. The two basic types of color film are called *daylight* and *tungsten*. (Review Chapter 4.)

Daylight film yields natural color when the subject is illuminated by the sun or by light of equivalent color wavelength, such as blue flash bulb or electronic flash. If you use daylight color film to take pictures under "tungsten" (that is, incandescent) light such as a reading lamp or a photoflood, the subject will have an orange cast.

Tungsten-balanced film is intended for use with room light or incandescent lamps. If you use it with daylight, your subject will have a blue cast.

You can use these color characteristics creatively to emphasize color or to create special moods; but most often garden photographers want their subjects to look as they do in real life. For this reason, if you cannot avoid exposing daylight color film by tungsten light, you can still get acceptable results by using a conversion filter.

72

For example, a blue filter (No. 80A) screwed onto the lens will yield acceptable results with daylight film when the subject is lighted by, say, incandescent quartz-halogen lamps. Professional-quality tungsten lighting units, such as the Lowel or Hervic fixtures, can also be fitted with heat-resistant filters that change the light to a "daylight" color.

The color quality of light is expressed in Kelvin units, or degrees. The higher the K number, the bluer, or "cooler," the light: Daylight, which is quite blue, rates at about 5200 K. You will see tungsten lamps listed as 3200 K or 3400 K. The eye sees very little difference between these two color temperatures, but color film does, and it is balanced for one or the other. For example, Kodachrome 40 is made to be used with 3400 K lights, while Ektachrome 160 is balanced for the "warmer" 3200 K lamps. Common photofloods are

3400 K, but they do not last as long as more expensive and stable quartz-halogen tungsten lamps, which have a color temperature of 3200 K.

You may decide to use 3200 K lamps but prefer the high quality of Kodachrome 40 film, which shows little granularity and has truer-to-life color. Kodachrome 40 can be exposed under 3200 K lamps with good results by using a light blue (No. 82A) filter over the lens to "cool" the 3200 K light slightly, thus giving the film the light it needs for accurate color rendition.

You can also go the other way, using a film balanced for 3200 K light—such as Ektachrome 160—under 3400 K photoflood or quartz lamps. Use a slightly "warming" filter (No. 81A).

Filters and Accessories

Both the light blue No. 82A and light pink No. 81A filters are useful for subtle color shifts in daylight photography, as well. For the most precise results, however, *match the film with the light source* as recommended by the manufacturer. (Review Chapter 4 for color temperatures.)

Special-effects filters

There are times when a special-effects prism may improve a photograph. For decorative views to be enlarged for display, or printed as greeting cards, a prism, a cross-screen, or a soft-focus effect can be appropriate.

Various types of clear glass *prisms* form unusual multiple images. Some leave the center clear but produce three, five, or six repeat images surrounding the subject. Another type forms a repeating image that can be shifted to repeat in any direction.

Cross-screen filters cause direct light sources and reflections to come out as stars. *Diffraction* filters, under such brand names as Colorburst, Color Halo, Rainbow, etc., turn reflections into rainbows. These effects look nice when the sun is shown above trees in a landscape or reflected in a water lily pond. When there is no direct reflection or point-source of light, the cross-star and color-diffraction filters have only a slight softening effect.

For variations on the *soft effect*, experiment with lip gloss or petroleum jelly spread thinly around the center

A 105 mm macro lens fitted with a multiple-image prism makes the viewer take a second look at *Renanthopsis* Fiery Gem. This orchid has peach-red flowers with dark spots and a compact growth habit.

of a clear or skylight filter, leaving the very center free. (Be sure to try this on a filter, never on the lens itself.) There are filters with this effect built in—a clear section in the center and frosted glass around the edge. The soft effect is greatest with wide apertures, less as the lens diaphragm is closed. With an SLR camera, use the depth-of-field preview to check what image the attachment will produce on film. Another type of soft-focus filter renders subjects equally soft at any *f*-stop. It can produce romantic impressions in landscapes and flower portraits.

Some of these are called *portrait* or *diffused-effect* filters.

Colored special-effects filters add various tints to photographs. Some are only colored on half the glass, some may be open on one half. The effects they give depend on the *f*-stop used. Other color filters are designed to be used with a polarizing filter, so that the tint can be varied in intensity—and sometimes even in hue.

Right: This zoom lens is a 70–210 mm. Its macro capability lets it focus this close without special attachments. Since parts of the amaryllis flower are now within the lens shade, however, full lighting is very difficult. *Below:* With the close-focusing zoom lens set at the 70 mm position, the film frame is filled with these amaryllis petals and anthers. For greater magnification, screw-in close-up lenses or an extension tube can be added.

More and more manufacturers now offer special-effects front-lens attachments in an interesting diversity. Your local camera store is the best place to start investigating the possibilities.

Getting Close

The least expensive way to focus close with a normal 50 mm lens on a 35 mm single-lens reflex camera is to use screw-in close-up lenses. These are thin supplementary lenses that look like clear filters. A set in three different powers (+ 1, + 2, + 4) is relatively inexpensive.

Supplementary magnifying lenses

Well-made sets will screw into each other. Charts that come with the close-up set show what image size is covered as each screw-in lens is used. In the set mentioned, the most powerful (+ 4) would be screwed onto the lens first, then the + 2, and finally the + 1, to make a total of + 7. They can be used in pairs, too, to give a + 3 or a + 5 magnification. For the best results in edge-to-edge sharpness, though, only one should be used at a time. Each time you add one piece of

glass to another in front of the camera's lens, "sharpness" suffers.

Nevertheless, simple supplementary lenses are easy to use, inexpensive, and satisfactory for many occasions. A 50 mm *f*/1.4 lens with a + 1 close-up lens will cover a subject area about 13 × 20 cm (5 × 8 in.) from 39 cm (15½ in.) away, or an area of 42 × 31 cm (18½ × 12¼ in.) when focused at 78 cm (30⅜ in.). This is perfectly acceptable for many flowers

and small plants. With screw-in close-up lenses, *no* additional exposure need be given. This is in contrast to extension tubes, bellows, and tele-extenders, all of which require longer exposures.

Inexpensive screw-in close-up lenses are available in many sizes to fit various cameras, but they are most easily used on cameras with direct through-the-lens viewing, such as 35 mm SLRs. Then you can actually see whether the edges of your subject look too soft. Using the smallest *f*-stops will improve edge sharpness. Sometimes slightly soft edges are attractive in flower portraits. If you want maximum definition at the edges, use a lens designed to focus close, such as the *macro* lenses or lenses used with a bellows or tube extension. The closer you can get to your subject, the larger the subject will look in the viewfinder and appear in the final photograph.

Extension rings and tubes

As the lens is moved farther away from the film plane, it can be brought closer to the subject. *Extension tubes*, sometimes called *rings* in the shorter sizes, move the lens away from the camera body and therefore from the film as well.

Rings of only a few millimeters are useful with telephoto lenses, which often will not focus closer than 1.8 m (6 ft); with even a short extension, such

Screw-in close-up lenses +0, +1, and +2 from Nikon are shown here with the instruction tables that are packaged with them.

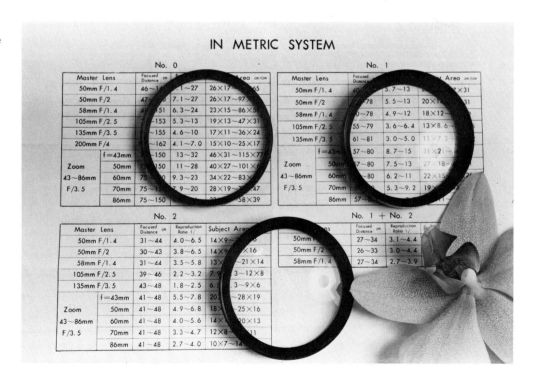

Filters and Accessories

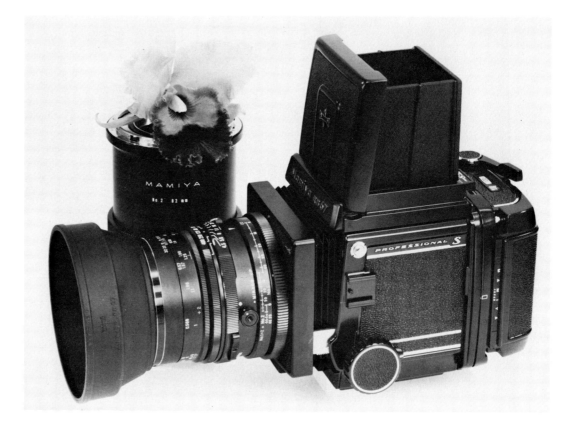

There are a number of single-lens-reflex cameras that take film larger than 35 mm, Hasselblad and Bronica among them. This Mamiya RB67 Pro-S camera uses 120 and 220 roll film and gives a 6 × 7 cm (2¼ × 2¾ in.) negative. It has an interchangeable back and film holder. An 82 mm extension tube (standing behind it) can go between the lens and the camera for extremely close focusing.

as a 14 mm ring, they can be used as close as about 1.2 – 1.5 m (4–5 ft) from the subject. These short extensions will need almost a half-stop more exposure. In-camera meters that read the light actually coming through the lens (TTL) will automatically compensate for extension rings.

The longer the extension, the more exposure increase is needed, and the closer a lens will focus. Extensions of more than 15 mm are usually called *tubes*. They look like a lens barrel without any glass. Automatic extension tubes, which permit full operation of automatic diaphragms, are available for popular 35 mm SLR cameras.

The quality of a lens is maintained with extension tubes; but, since the tube is a single length, you will need more time than when using a bellows (see below) to add or subtract rings if you want to vary the size of the image in the viewfinder (and on the film). You can combine extension tubes with screw-in close-up lenses or with tele-extenders (teleconverters) to get even closer to your subject; for example, a macro lens9 that will deliver a 1:1 (life-size) image can be coupled to an extension ring or tube, then to a 2 × extender. Extensions are less expensive than a macro lens or a bellows, but they are less versatile.

Reversing rings

For even greater magnification of tiny flowers, reverse the lens. Make an arrangement that starts with the camera body, then an extender (also called a teleconverter), then the extension tube, finally the lens screwed on back-to-front with the aid of a special adapter ring. Reversing a lens produces sharper results at magnifications larger than life size, but it also will disconnect the automatic diaphragm on cameras that have automatic exposure control. You must open the aperture manually to focus, then stop it down again before making the exposure.

A normal camera lens can be reversed to focus close. Here a 50 mm lens has been turned back to front with the help of a reversing ring. An extension tube protects the rear glass (now in front) and provides a button to open the diaphragm more easily.

This is the photograph made with the setup shown above, a small pink *Phalaenopsis* David Herbert. A reversed lens gives sharper details than screw-in close-up lenses do, but its area of sharp focus is quite small. A macro lens and bellows units are more versatile.

Bellows

When you wish to photograph small subjects in a life-size ratio (1:1) or larger, a bellows is useful. The bellows is flexible; so you can quickly adjust the length (that is, the distance from the lens to the film plane) to accommodate subjects of various sizes. By going two steps further and using a 55 mm macro (close-focusing) lens *reversed* on a bellows, you can get an image on the film that is three times

the size of the original subject. Note that on some bellows devices use of a double cable release makes it possible for the lens to function automatically.

To get such a 3 × magnification you will have to give an exposure increase of about four *f*-stops. Through-the-lens meters will figure the exposure for constant light—either the sun or incandescent lamps. For flash, though, you must remember to open the lens aperture manually or increase the light intensity as called for by the amount of bellows extension: The longer the extension, the more the exposure must be increased, because light is lost as a lens is moved farther away from the film.

The most convenient bellows attachments for plant photography have twin tracks. This means that you can set the bellows extension for a given magnification, then move the whole assembly back and forth for best focus; this is much easier than moving the subject or using the bellows extension to adjust the focus. Many bellows devices are made to accept slide-copying accessories. These are useful for copying or cropping slides.

Lighting the close-up: Ring lights

When doing this sort of larger-than-life photography, it may be difficult to get light on your subject. Often a ring light electronic flash is the best solution because it attaches directly around the lens and will light

A bellows attachment on a 35 mm SLR permits photos at greater than life size. It is best used on a tripod. A double track allows the whole unit to be moved in and out for focusing. The lens is a short-mount type made for use with bellows.

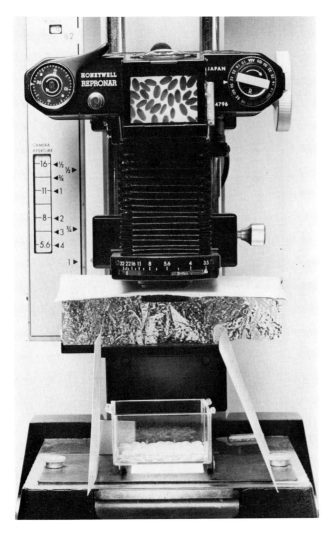

Left: **This slide-copying device can be used to photograph small flowers, foliage, and seeds. There is a built-in electronic flash aimed upward from below; arranged white cards and a homemade aluminum reflector have been added this time to bounce light back from above onto some seeds in the clear plastic box (they can be seen in the viewfinder).** *Below:* **Here are the wheat seeds photographed on the Repronar, as seen at left. Because some light was bounced back into the top of the box, the seeds do not appear simply as silhouettes.**

a tiny subject evenly, even though the flower may be almost inside the ring light with a 50 mm lens. The lighting is even, with fully open shadows, and is suitable for scientific-style photographs because all parts of the subject receive the same flat, frontal light. If it is too flat, you can combine a ring light with an electronic flash unit positioned to one side to show texture or to create some shadows for three-dimensional modeling, or depth. A few advanced units (such as the Bowens Texturelite and the Canon Macrolite, which can only be used on Canon's A-series cameras) have several flash tubes. Since each of the

Texturelite tubes can be controlled separately, the light can be made more directional than can the light from a simple single-tube ring light.

The most sophisticated ring lights offer a range of power, so that you can tailor the flash output to distance and film, and also of power sources, from a portable battery to house current. Ring lights are best for subjects from 2.5 cm to 30 cm (1 in. to 12 in.) away from the lens.

Depth of Field

The *zone of acceptable sharpness* is most important in close-up photography because the closer you are to the subject, the less depth of field you have to work with. In front of the actual point of focus (and behind, as well)

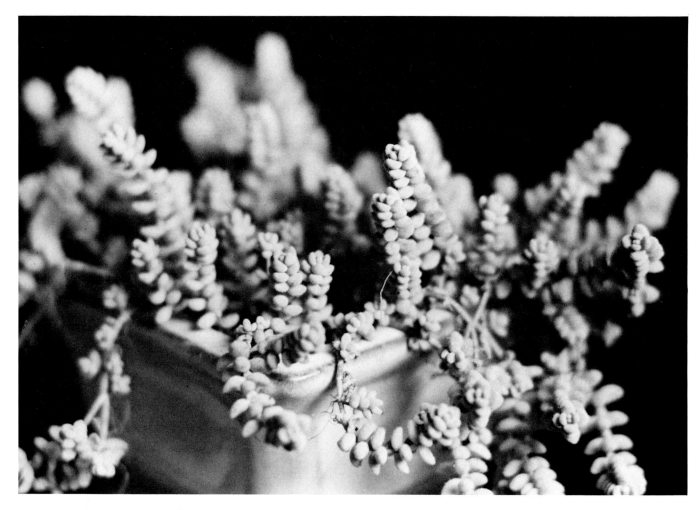

This study of a miniature sedum clump was taken at *f*/5.6 with a +2 close-up lens on a 105 mm *f*/2.5 Nikkor lens. Compare this picture's over-all sharpness and depth of field with the next photograph of the same plant.

will be an area in which the image looks "sharp"—detailed—to the viewer. The sharpness is "acceptable" if *you* are satisfied with the clarity and definition of details *in your final print or projected slide.* When slides are projected or images enlarged to moderate size, the depth of field will be seen to include a limited area. One third of this area is in front of and two thirds of it are behind the actual distance at which your lens was focused. This zone of acceptable sharpness increases with small *f*-stops (lens openings) and decreases as the diaphragm is opened to larger *f*-stops.

More or less

The depth of field is one of many artistic controls at the photographer's command. You can vary the in-focus area to suit your vision. If you are photographing a garden and wish some tree branches and a bed of flowers at 90 cm (about 3 ft) to be sharp but prefer the distance to be a soft blur, set the lens at a large opening, such as *f*/3.5 or *f*/2.8. If you prefer to have near *and* distant subjects appear

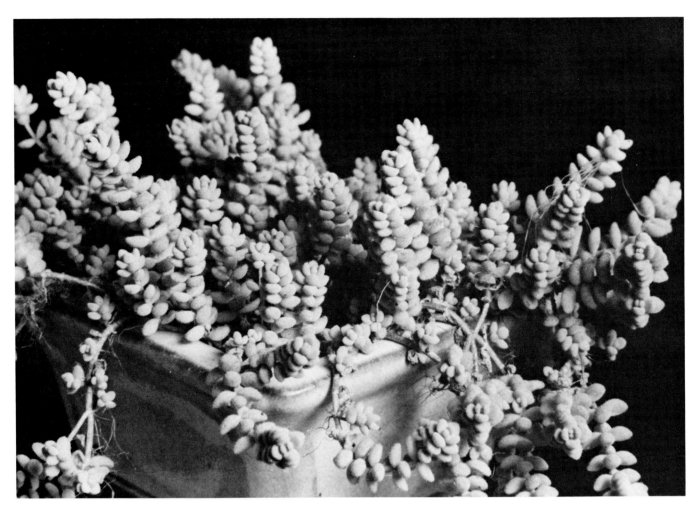

Here the sedum was photographed with the same lens combination but at an extremely small lens opening—*f*/32. Light for both of these photographs was from a single 250-watt photoflood in a 12-inch reflector, placed at the photographer's right.

sharply detailed, make the exposure at a small lens opening, such as *f*/11 or even *f*/22 if your lens closes down that far. Depth of field becomes very shallow in extreme close-ups, increases as the lens is focused on more distant objects.

Checking the "preview." As was explained in Chapter 3, advanced cameras in SLR design have a "preview" that lets you check the depth of field: Pushing or sliding this control closes the lens diaphragm to the size the

opening will have when the actual exposure is made. (Most modern lenses for SLRs have automatic diaphragms that stay open until the moment of exposure.) The viewfinder may darken because you have closed the lens down by using the preview control, but you can still get an idea of how deep the field of sharp focus will appear in the final photograph.

Using tables. A more accurate determination than the through-the-lens "preview" can be made with the tables supplied in most instruction manuals that come with cameras, close-focusing lenses, bellows, and

A right-angle finder screws into the camera's eyepiece, making composition and metering easy even when the lens is close to the ground. Low angles dramatize growing plants by looking *up* at them.

screw-in close-up lenses. These tables show the depth of field available at various *f*-stops and focusing distances. The tables are interesting, but many photographers prefer to rely on their own tests, experience, and actual observataon of depth of field through their own equipment.

Using the lens scales. The lenses for modern cameras have depth-of-field guides on the lens barrel. The markings are color-coded to the apertures, or lens openings, since depth of field is directly related to these.

To check the area of acceptable sharpness, first focus on the point of maximum importance. For example, in photographing an azalea 1.5 m (5 ft) away, focus on the branch or section you want to be sharpest. Now set the *f*-stop you will be using, *f*/4. By referring to the lines on the lens barrel, you will see that at *f*/4 everything

from about 1.4 m to 1.8 m (4½ to 6 ft) away will be acceptably sharp.

To summarize:
· Refer to lens markings as a check on what depth of field your lens will provide at various *f*-stops and distances.
· Check depth of field through the lens with the preview control.
· If you need still more precise information about the depth of field, consult the tables supplied with your equipment.
· Finally, with experience you will soon learn to control depth of field and should be able to select an *f*-stop that will give sharp focus where you want it.

Really close

With extreme close-ups, such as when you are filling the 35 mm frame with a flower about 5–7.5 cm (2–3 in.) tall, you will find that focusing one third into the subject area will give the best over-all sharpness. With a complex flower such as Lady Slipper (*Paphiopedilum*), or a deep subject such as an Easter Lily seen from the front, for example, you will want to have 5–8 cm (2–3 in.) in acceptable detail. If you focus at midpoint of the flower, the area behind may be in focus while the part closest to the lens is not. Therefore, focus on a spot slightly closer to you than the halfway point. By using this technique, along with the smallest openings your lens offers, you usually can bring the whole of complex flowers into acceptable sharpness. Naturally, with flat subjects, such as a daisy or a caladium leaf photographed straight on, the depth of field required is less.

Minimum depth of field

Perhaps you prefer to have all but a small portion of the subject in soft focus. This technique forces the viewer to concentrate on a specific part of the plant. One might choose to focus on the sharp spines of a cactus, with a lens opening of $f/5.6$ or even $f/3.5$. Such a technique will render the plant itself "soft" (out of focus) but have the spines looking "sharp." Combined with side lighting, this technique can produce a dramatic photograph that emphasizes the spines.

When you work as close as this, lighting may be a problem. Here a ring light surrounds the lens to give soft, even illumination to the *Saintpaulia* (held in position by an alligator clip). A coiled PC cord connects the ring flash unit to the camera's shutter release. The close-up setup here consists of a 35 mm SLR camera body, extension tube, 2× tele-extender, a reversed lens, and the flash unit.

Other than SLR cameras

Taking close-ups with a *twin-lens reflex* camera is slightly easier than with a rangefinder because precision accessories are available for parallax correction. The difference in angle of view between the viewing/focusing lens and the taking lens (that is, the parallax) is not extreme in medium-to-long views; but as subjects get closer, the difference increases. For anything closer than 1 m (about 3 ft) the parallax error must be corrected or you will lose part of the image.

To get some degree of precision, place a close-up lens of the same power— +2, for example—over both the upper (focusing) lens and the lower (taking) lens. Use a tripod. After careful focusing, mark the height of the tripod, then raise it enough to bring the taking lens into the same position as that previously occupied by the focusing lens.

Even easier are *parallax-correcting close-up sets,* consisting of two close-up lenses of equal power. The one for the upper (focusing) lens has a prism that shows an image almost identical to that of the lower (taking) lens. You still cannot see the depth of field, but if you already have a twin-lens reflex and want to use it for moderately close views, a set of parallax-correcting close-up lenses is a good investment. A +1 power set permits most 2¼-square-format twin-lens reflex cameras (such as Rollei, Yashica TLR, etc.) to focus at 97–51 cm (38–20 in.). A +3 set lets the camera come as close as 33–25 cm (13–10 in.). Some camera lenses will not accept these attachments; so check with your camera store or, if you are ordering by mail, send complete information about your equipment.

Rangefinder cameras are designed for quiet action, compact size, and easy viewing. When a subject is less than 1 m (or 3 ft) away, though, parallax makes precise focusing and composition impossible: There is too much difference between what you see through the finder and what the lens sees. Even with some of the aids listed below, rangefinders are still less precise than single-lens-reflex cameras, which let you view through the taking lens.

Close-up aids for simple cameras. When you cannot look through the lens or use a rangefinder with close-up accessories, you can still get reasonable medium-close-ups. When using clip-on or screw-in close-up lenses, use the tables supplied with the close-up attachment to determine the correct distance between subject and lens. To save time, cut a piece of string the right length and tape it to the camera below the lens (allow for the extra distance between lens tip and camera bottom). Then, when you want to take a close-up, stretch the string out to the subject and the camera will be at the correct distance.

A stiff wire focusing frame can also be used to indicate how far away the subject should be and the general area that will fill the frame on the film when any given close-up attachment is on the camera. If you are planning to do more than casual close-up photography, an SLR camera will save time, film, and frustration.

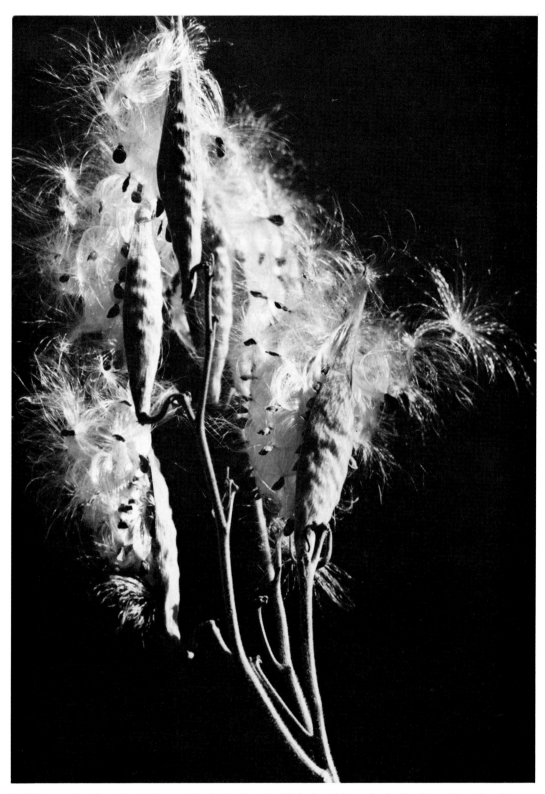

Sunlight streaming through a window provides bright directional light that picks up the details of the milkweed seed pods and the hairs on the stem. The delicacy of the plant (*Asclepias*) is further accentuated by contrast with the deep black of the background card. The photograph was taken with a Nikon F, a Nikon E2 extension ring, and a 105 mm lens at *f*/16.

6

Light and Lighting

As paint is for the painter, light is for the photographer the medium of an art. The *direction* and *quality* of light largely determine what the photograph will look like. The *amount* of light will determine the choice of film and—maybe—lens. Naturally, adequate light for correct exposure is needed, but this is only the start. How you manipulate the light, use or change its character or direction, will greatly influence the effectiveness of each photograph. You can even change the sunlight by diffusing, reflecting, and varying the angle at which it strikes your subject.

Adding Light to the Scene

Artificial light is easier to control. By using diffusers, barndoors, reflectors, different types of lamps, and adjustments of lamp height, you can produce hard, medium, or diffused light from any direction. The style of lighting you use will depend on your personal preference and on your subject's characteristics. It may also depend a little on what your camera and your film can do.

For example, I prefer diffused or indirect light for flower portraits, but blossoms with rough texture, hairs, or fringing often loose their character if the light is too soft. In such a case a more directional light might be used, or one could provide an over-all diffused light, then add a direct backlight or sidelight to emphasize the special features of the subject.

Light and Lighting

Sunlight rakes across the underside of a giant tropical water lily leaf (*Victoria regia*), emphasizing structure and texture. Directional light coming from a low angle casts deep shadows, which can add drama to photographs.

Diffused Light

In color photography of plants, soft, diffused light is especially useful because it reveals all parts of a subject without dense shadows that would hide important details. Harsh, direct light can be dramatic, but is not appropriate when you wish to show all parts of a delicate blossom.

Cloudy-bright days are excellent, but when the sun is direct it is better to soften the rays for an indirect lighting effect. This can be done with diffusion material or a common white household sheet, or by bouncing the sunlight into a reflector and then at the subject. On a sunny day, put your subject under a sunlight-diffusing sheet or tent, then place a reflector where it will bounce enough of the direct light back at the subject to show modeling or emphasize important features. This technique is good with orchids and foliage plants.

Indoors, diffused light can be arranged by using *Mylar, glass-fiber*, or *frosted diffusion material* in front of direct light sources. Usually less than one stop of light loss results from these frosted diffusion fabrics. Mylar diffusion materials are offered by makers of studio electronic flash units and by professional lighting-equipment supply firms.

With some devices, such as a light cabinet or box for small subjects, *frosted glass* or ground glass could be used; but glass is heavier and harder to work with than the flexible frosted fabrics. My large photo table has a

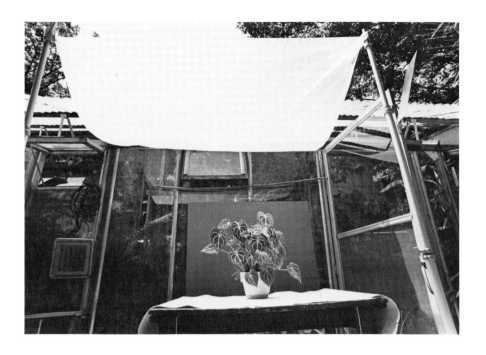

For some subjects, indirect light is more suitable. Direct outdoor light can easily be diffused by putting up a canopy of plastic diffusion material. *Left*: This setup uses a Lowel Sun Diffuser curtain supported by Lowel Link Stands and the greenhouse behind. *Anthurium clarinervium* is set in front of a colored mat board, with white paper underneath to bounce light back into the shadows. Only foliage against a background will show in the final picture. *Below*: Sunlight was filtered through frosted diffusion plastic over a window at the left; reflectors to the right and below bounced light into shadow areas. Because diffuse light has a "wraparound" effect, it is excellent for recording fine structural details on a subject such as this *Cattleya* Cherry Chip.

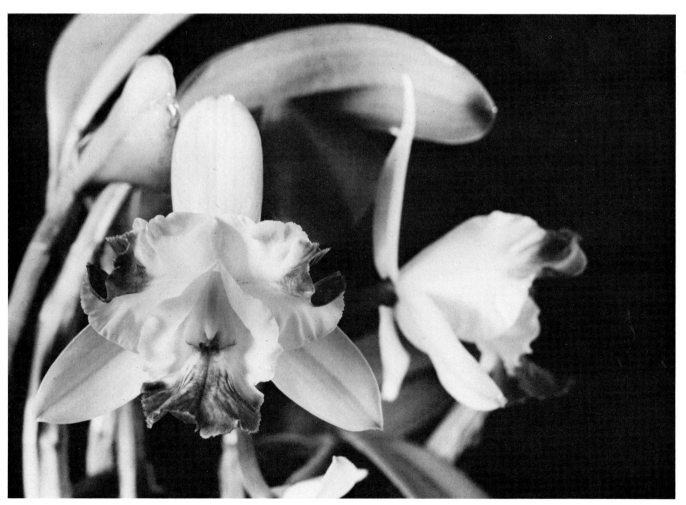

Light and Lighting

In the studio, light can be softened by either pointing the light source at a white umbrella or other reflector (as seen at left) or by diffusing the light through a translucent material (as seen at top right). In this studio setup, a smaller electronic flash (at the right) is aimed directly at the subject to highlight texture. The 105 mm lens mounted on the camera takes in only the miniature rose and the black backdrop.

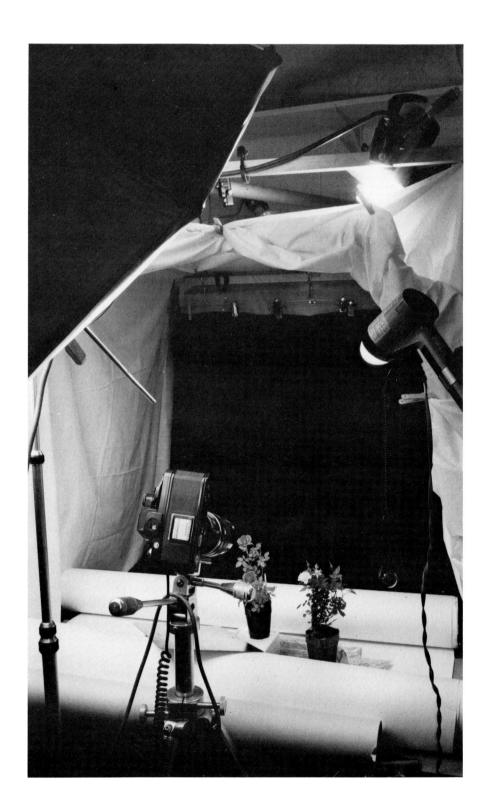

frame over which I can stretch a *tent* consisting of a plain white muslin sheet. By positioning electronic flash (strobes) directly outside the sheet, aimed toward the subject, I get a wraparound, diffuse light. When shooting in color, this is delightful; but for black-and-white work the results can be too flat. In the latter case, the addition of a small direct light, usually from the side, increases contrast and produces more interesting photographs.

Some lamps come in frosted versions. The *frosted lamp bulbs* deliver light that is slightly less harsh than that from clear bulbs, but it is not really "soft" enough to be called "diffuse." Combining frosted lamps with *soft reflectors* produces still softer light.

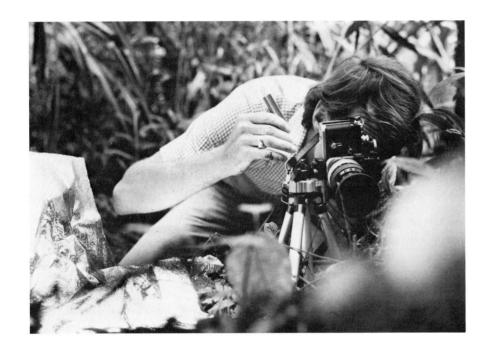

Reflectors can be used to concentrate and direct light. Here, in dappled jungle light, the photographer uses a sheet of reflection material to throw more light on his subject. The camera is supported by a portable tripod for a slow exposure using a macro lens.

One excellent fixture design, the Lowel Softlight, uses two tungsten-halogen lamps inside an aluminum fixture. A soft reflective material, held on a frame by Velcro tabs, produces a bright indirect light with soft shadows. An excellent two-light studio arrangement can be fashioned using one Softlight for general wraparound light (it will even illuminate the background) plus one direct quartz-halogen tungsten light fixture to provide brighter directional light.

Reflected light

Artificial light can be reflected from a *white card* or from a professionally designed *umbrella* unit that accepts electronic flash or tungsten light, then bounces it back onto the subject to "fill" shadows (that is, show more detail). Fashion photographers often use light reflected from big white or silver umbrellas to give diffused surrounding light with soft shadows, glamourizing models and clothes. The same technique can create striking plant photographs. Powerful studio flashes aimed into the umbrella are reflected back toward the subject. Adding backlight or sidelight with direct or only slightly diffused electronic flashes can tailor the effect to each subject.

Frosted diffusion material stretched over the umbrella will produce even softer light.

What the light is reflected from is important, especially in color, when the reflective surface can add a color-cast. Light bounced from gold foil or a yellow wall makes yellow flowers look richer but would be annoying if used with pure white blooms. White reflectors, such as white umbrellas and matte white cardboard, produce flat light with very little contrast. Aluminized Mylar and metallic fabrics reflect crisper light, which creates a livelier look. Shiny metallic reflectors produce a sharp beam that almost resembles direct light.

Light and Lighting

Even if you choose to do most of your photography in sunlight, separate reflectors can play an important role by filling in shadows to *reduce contrast* in harsh light. Excessive contrast is especially bad when photographs are to be published or enlarged.

Reflectors in fixtures are usually permanent, such as the bowl design seen for photoflood lamps. Sometimes a bulb itself may be coated to produce an integral reflector, like the *reflector floods* and *spots* so useful for lighting gardens at night. These lamps can be used for photography, too.

The reflectors you will find most useful are those used to bounce light from any source to parts of the subject that need lightening. My favorite small reflector for at-home use is a 20 × 30 cm (8 × 12 in.) stiff metal sheet coated on one side with a mirror finish and on the other side with a pebble finish for softer reflection. The shiny mirror side will direct a beam of sunlight quite some distance. For example, when the reflector is in full sun, it can redirect a strong stream of

A white card works as a reflector to throw light into shadowed areas. The added light reduces contrast between highlight areas and the shadow side of the subject. Hidden in the leaves are dark purple *Iris reticulata* flowers, which show up against the brown oak leaves in color photographs but in black-and-white are almost the same shade of gray.

A portable reflector supported by a stand (*top picture*) filled in shadows for the shot of 'Red Hot' peppers, 'Queen Sophia' marigolds, and 'Butterboy' squash (*lower picture*). The reflector, a Lowel Variflector II, is finished in Mylar and can be adjusted to throw light in a variety of ways. A blue card behind the planting provided the clean-looking background.

sunlight onto a plant growing in the shade. The mirror side is also useful for reflecting strong sidelight across cactus spines, fuzzy foliage, and rough bark to emphasize shape and texture. The pebbled silver surface is appropriate for filling in shadows when set up in a position opposite a main light source: With a key light at the right and a reflector at the left, you can get nicely balanced lighting with a minimum of equipment. (The one I use is called Tota-Flector and is made by Lowel-Light Manufacturing, Inc. It has a socket to accept a flexible metal support called the Flexi-Shaft, a strong metal rod that can be bent in any direction to control the reflector beam.)

A soft reflected light, such as from a pebbled silver surface, is also useful below flowers to *add a bright line* around darker subjects.

Less elaborate reflectors can be fashioned from heavy-duty *aluminum foil*, crumpled and then flattened out and bent over stiff cardboard, ply-wood, or pressed board. Many small wrinkles in the foil scatter the light,

Light must be kept from reflecting into the lens, or the photographs will be washed out by glare. This 105 mm macro lens has a built-in lens shade, but with a diffuse light source (such as the Opalite Mylar unit on the Balcar electronic flash used here) it also helps to add a small black metal Tota-Flag (from Lowel-Light) or a piece of black cardboard.

making better illumination than the hot spots reflected by smooth foil. Attach the foil to the backing with double-sided tape or glue. For temporary use, simply bend the foil around the backing; a few inches of tape on the back will hold the foil tighter.

Reflectors of foil are useful with small subjects, since a section of foil can be bent to stand by itself, or wrapped over a small folded card that will stand on a table; or spread the foil directly under the subject to bounce toplight or sidelight back into the composition.

A more *uniform reflective surface*, and a much tougher material than plain foil, is available from photographic supply houses. One brand, Roscoflex, is sold in rolls and in large single sheets. The silver surfaces come in mirror, soft, and supersoft finishes; gold and colored surfaces are also offered. The backing is tough and flexible. The soft finishes are best for fill-lighting of plants.

Lightweight frames, available from a few manufacturers, turn these materials into easily portable reflectors suitable for field photography even in the jungle.

White *poster board* makes an inexpensive but effective reflector. Since poster board is awkward to carry, especially in large sizes, it is best suited for use in the home, studio, or nearby garden. Colored poster board, useful for backgrounds (as shown in Chapter 2), often has a pure white side that can double as a reflector. In the studio, a hanger with a pair of clips can be used to hang the board. Small sheets can be propped against a bookend or similar heavy object, but larger sections are less likely to droop or fall when suspended from sturdy stands.

For occasional use, a section of Roscoflex or similar metalized surface can be held to the poster board with clothespins. A matte-white poster board gives very soft full light, while foil surfaces provide more contrasty effects.

Mirrors can be used as light reflectors. They will send back the same type of beam as the one that strikes them. Small dental mirrors are useful for directing light into tiny flowers or seed pods. They can be held in clamps for convenience.

With careful placement of lights and camera, mirrors can even be used as backgrounds. Mirror backgrounds can give depth and often can show important features on the backs of flowers, even while they throw light on them. Look through the camera to be sure no light is shown as a *direct* reflection. Be sure you do not use mirrors as reflectors or backgrounds when you are using small electronic flash units that do not have "modeling" or "focusing" lights to show just how and where the flash will fall and bounce back.

The Larson Strobasol electronic flash unit can be fired into a Reflectasol umbrella for diffused lighting effects. A built-in modeling light shows what the final illumination will look like. Setups like this can be put together from many different sources.

Light and Lighting

Strong light and a sharp shadow pattern are welcome compositional elements in this photograph of citrus trees and deeply carved buildings at the Alhambra in Granada, Spain. This kind of lighting shows off the texture of the leaves and the carvings.

Sunlight

Photographing with sunlight is the least expensive way. You need not buy any lighting equipment, just a few reflectors and perhaps a diffusion screen or sheet to control this gigantic free light source. Much location photography outdoors, at botanical gardens, in the wilderness, or your own garden, can be done with sunlight alone. Portraits and close-ups, and even many indoor subjects, can be lighted by the sun; but a few precautions are necessary.

Color changes

The color of sunlight changes during daylight hours. Early morning and late afternoon sunlight is warmer than midday sunlight. Daylight color film is balanced to give the best results between midmorning to midafternoon. Color photographs taken at other times will have a tint, usually "warmer" (redder). For example, a

LIGHT SOURCES—ADVANTAGES AND DISADVANTAGES

Light Source	Advantages	Disadvantages
Sunlight	1. No cost 2. Easy to meter 3. Natural looking	1. Variable in color 2. Subject to weather 3. Not available at night 4. Can change during use
Photoflood lamps	1. Inexpensive 2. Widely available 3. Easy to meter 4. Lighting effects easy to view	1. Hot 2. Color changes with age 3. Limited beam control 4. Limited professional accessories
Tungsten-halogen lamps	1. Wide variety of fixtures 2. Units made for professional use are tough and versatile 3. Lamp color remains constant with age 4. Easy preview of effects 5. Metering is easy	1. Hot 2. Moderately expensive 3. Use lots of electricity (500 to 1500 watts)
Continuous-light sources in general (sun or lamps)	1. Any shutter speed possible 2. Easy preview and metering	
Flashbulbs	1. Small, portable 2. Inexpensive for infrequent use 3. Color constant 4. Rapid firing with many simple cameras using bars, cubes 5. Available for most simple cameras	1. Limited control of beam 2. Expensive when many bulbs are used 3. Intensity not easy to vary 4. Bulbs must be changed after each sequence or flash 5. Correct exposure may need calculations
Electronic flash in general	1. Color is constant 2. Easy to vary intensity on many units 3. Useful accessories available 4. "Freezes" subject motion	1. Special metering needed 2. Subject to failure and may need expensive repairs 3. Not all cameras synchronize with electronic flash.
Portable battery-operated units (small to medium size)	1. Easy to carry 2. Inexpensive when flash is needed often 3. Several types and power options 4. Many models widely available	1. Limited control of beam 2. Limited power 3. Larger units expensive for occasional users 4. No precise preview of light effect
Studio electronic flash units	1. Built-in focusing or modeling lamps 2. Powerful 3. Easily adjusted intensity and beam 4. Most professional units well designed, sturdy, versatile 5. Wide variety of accessories	1. Expensive 2. Heavy 3. Require house current or special generators 4. Repairs may be difficult except in major cities.

pink azalea photographed at 10 or 11 in the morning on daylight-balanced color film will look pink. Photographed at 4 or 5 in the afternoon, it will look orange. Filters can correct for these effects (review Chapter 5).

Sunlight is subject to rapid changes in intensity as clouds pass by. This can be frustrating when you are trying to get accurate photographs, as you must keep adjusting the exposure (and color-compensating filters, perhaps) as the clouds pass over. Naturally, clouds may also stay around; and if rain comes, the light will be too flat for satisfactory results, especially in black and white.

Under frosted no-color fiberglass or white-shaded glass in a greenhouse, full sun gives lovely wraparound lighting. A metallic reflector and a tripod for slow exposures are useful then. Beautiful flower portraits can be taken in this diffuse light, as long as no breeze stirs close-up subjects.

Outdoors, the situation is different. To get maximum depth of field you must use a small aperture, $f/16$ to $f/32$ (if your lens closes this far). Slow exposures are required when you use these smallest f-stops, of course. With exposures between 1/60 sec. and 1 second, the slightest movement by the subject will cause blur. The larger the subject looks in your viewfinder, the more the blur will show. Trying to get sharp close-ups outdoors on a breezy day can be a frustrating experience. One can wait, it seems for hours, until the flower stops bobbing about in the viewfinder frame. The wind will usually start just as you decide to release the shutter. Temporary wind barriers, such as clear plastic sheets or white cardboard to the sides where they will not show in the picture, may be some help in slowing down the wind without causing shadows.

If shallow depth of field is acceptable, you can avoid showing blurry subject movement by increasing the shutter speed to 1/125 sec. or faster (opening up the f-stop to compensate, of course). These considerations do not occur when you use electronic flash, since in most cases the short burst of the flash "stops" any subject movement.

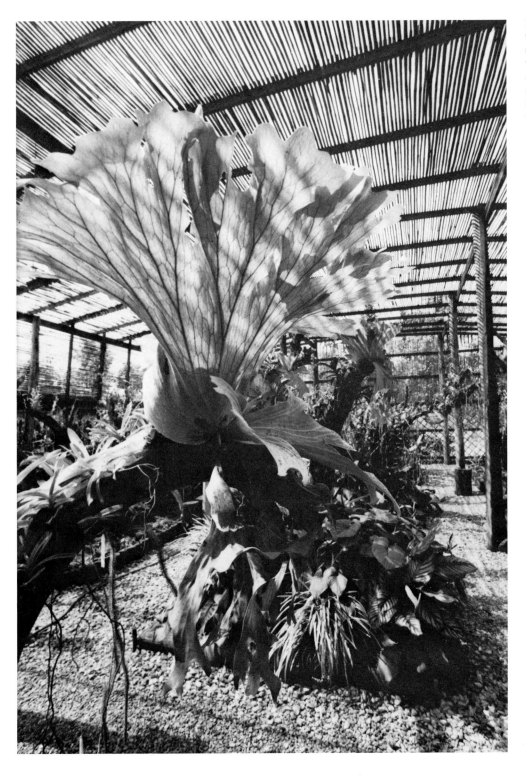

Patterns of light and shadow through bamboo lath at a nursery in northern Thailand provide a dramatic background for a tropical *Platycerium* fern, but a plain fiberglass or glass roof free of distracting shadows would be better for most flowers.

KVCC KALAMAZOO VALLEY COMMUNITY COLLEGE LIBRARY

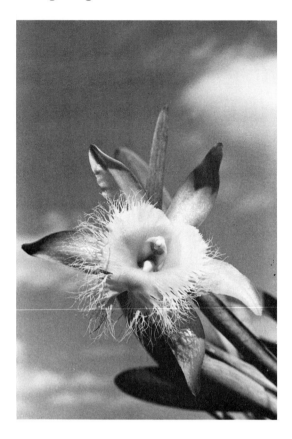

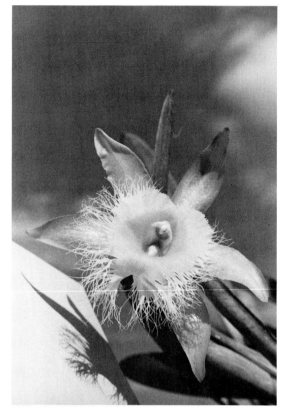

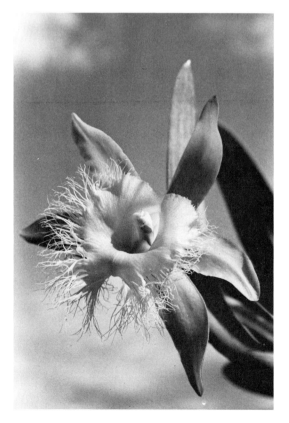

Above, left: **The sunlight came directly from in front of this *Brassavola Digbyana.* No reflector was used, and dark shadows formed under the curved parts of the orchid's flower. Compare this photograph with the one** *above right,* **for which a white card was added as a reflector. The card was allowed to show in the picture to demonstrate how shadows will be lightened in the final photograph.** *At left,* **the sun was directly to the side of the subject. No reflector was used to fill shadows, but still details show in the flower, and the characteristic fringed lip is emphasized.**

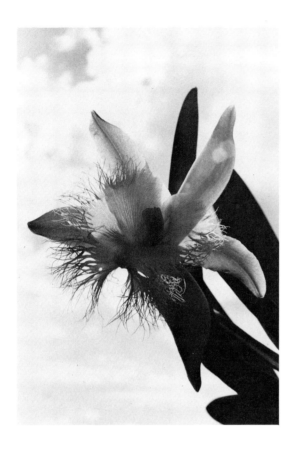

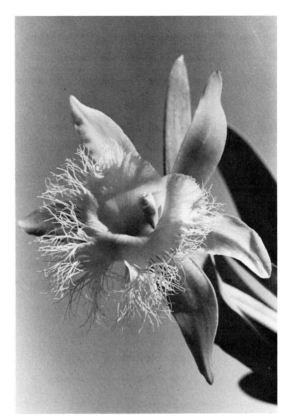

Above, left: **With the sun directly behind the subject, lens flare becomes a problem. Here, it results in the white area on the upper left-hand petal. Flare is caused by the light's reflecting between the glass lens elements inside the lens. When the camera is adjusted so that no sunlight strikes the lens directly, the effect of backlighting becomes much more attractive, as we see** *above right*. **When the shot at the** *right* **was made, the sun was behind a cloud. The sky now provides a plain background for the flower. The soft, diffused light is also characteristic of sunlight on an overcast day.**

All these photographs of *Brassavola Digbyana* were taken with a Vivitar 70–150 mm close-focusing zoom lens and a yellow-green filter. The orchid is a greenish cream in color.

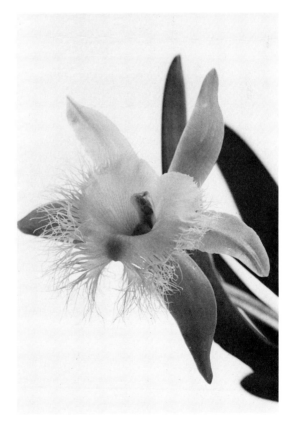

Close-ups are not the only plant-photograph situation where movement might spoil the results. Trees, especially when in full leaf, will often show blur from movement at moderate shutter speeds of 1/15 sec. to 1/125 sec. Be prepared to use a fast shutter speed to "stop" or "freeze" fluttering foliage, unless you want the blur in your final picture. Select a film with enough sensitivity, or "speed" (high ISO rating), to give you a fast shutter speed combined with a small *f*-stop, for adequate depth of field.

Artificial Light

Using artificial light requires some practice to get the best results but, once mastered, it offers constant performance unhampered by weather. The equipment will depend on the budget and on the subjects to be photographed. (The lighting-sources table should help you here.) One of the least expensive, yet most versatile for hobby use, is a photoflood lamp. These lamps are moderately priced and suitable for many situations.

Photofloods

You can judge lighting effects easily when using photoflood lamps. By activating the camera's depth-of-field preview you will be able to see the zone of sharpness, shadows, contrast—all the useful information, especially with portraits or complex subjects.

Photofloods screw into standard sockets, but they are better used in ceramic sockets to avoid problems from heat. They work well with inexpensive bowl reflectors and can also be directed into umbrellas, aimed through diffusion screens, or bounced off big reflectors. Some have a reflective coating inside the lamp, but most

The Lowel Softlight, as its name suggests, gives a gentle light. The reflective fabric shell of the Softlight diffuses the output of the powerful tungsten-halogen lamps.

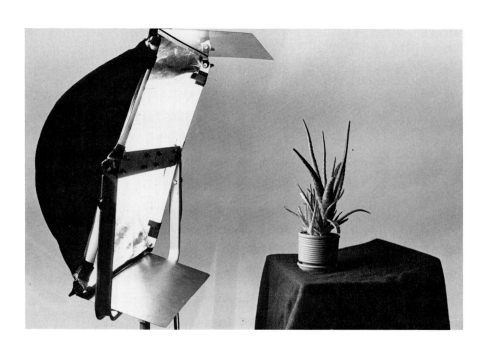

are designed to be screwed into a combination socket-and-reflector fixture.

Two types of photoflood reflector holders are usually offered in photo stores: a clamp-on design that grips by spring action (useful if there are poles, stands, or other supports) and a socket that fits into a stand. Stands have the advantage of height adjustability and portability. Of course you can clamp spring-grip reflector holders onto a stand, but they are likely to slip and are more difficult to adjust.

The major advantage of photofloods over moderately priced electronic flash units is the ease of seeing just what the light is doing. In fact, any tungsten light has this advantage over small flash units that do not have modeling lights like the ones built into expensive studio electronic flash units. *Modeling lights* are constant-light sources which have low power but which let you see where the light from the final flash will fall. Small reflector spots held next to an electronic unit that does not have such a lamp can give an approximation of what the final flash lighting will look like, although with less precision.

Light from photofloods, as from other tungsten fixtures, can be read directly with hand-held or built-in camera meters, eliminating the need for flash meters or distance calculations.

With Kodachrome 40 film (3400 Kelvin balance), shutter speeds must be slow to allow maximum depth of field. Using No. 2 photoflood lamps of 250 watts in a 30-cm (12-in.) bowl reflector 51 cm (20 in.) from a flower, an average exposure would be 1/8 sec. at f/11. A tripod must be used and the subject has to be perfectly still. Use a cable release, or the camera's built-in self-timer, to avoid camera movement during exposures slower than 1/30 sec. The camera *and* the subject must both be perfectly still during long exposures if you want to achieve sharp pictures. Camera shake or subject movement will cause blur, even when the focus is perfect.

If you use air conditioners, fans, or open windows to keep the room cool, be sure that moving air does not cause your subject to shake. Even shaky floors can cause subject movement. Some small flowers on stiff stems will remain still even though air currents are moving around. Other blooms, usually those on thin stems, will move with the slightest breath of air. If you photograph small subjects frequently, and must do so where they are likely to move, you will find electronic flash less frustrating than either photoflood lamps or natural light.

To summarize: Advantages of photofloods are their low cost, wide availability, ease of previewing lighting effects, and convenience of exposure metering. Major *disadvantages* are a slight change in color temperature as lamps get older (producing redder results on color film), heat that may wilt plants, and a broad light beam that is hard to control in comparison with other constant-light sources.

Light and Lighting

Tungsten-halogen lamps

Tungsten-halogen lamps, especially the quartz-halogen type, are common in professional studio lights, and most lighting fixtures for motion pictures and location television use them. Although these lamps are more expensive than photofloods, they offer several advantages:

- the *color* remains constant with age;
- the lamps remain at the same *brightness* until they burn out;
- there is more *control* of the spread and quality of the light because they can be focused, and reflectors, diffusers, lenses, and barndoors are available for these fixtures.

Tungsten-halogen quartz lamps come in several different sizes and Kelvin ratings, and both frosted and clear. For plant work, the frosted may be preferable because they provide diffused light. For color photography, use 3200 K lamps with Ektachrome 160 and similar Type B films; with Type A films, such as Kodachrome 40, use lamps of 3400 K. The difference between 3200 K and 3400 K is slight (see Chapter 4), but for the truest color in the final image, match the film's color balance to the lamp's Kelvin rating as recommended by the manufacturer.

CAUTION: Tungsten-halogen lamps should never be touched with bare fingers, *even when cold.* Skin oils

This Hervic tungsten light is shown with a diffusion screen in place. The device, which uses a 650-watt quartz lamp, has built-in barndoors for directional light control. Barndoors are available as accessories for most studio lighting systems.

and salts will cause the quartz shell to blister, and so reduce its life. Use a tissue or clean cloth, or the paper new lamps are wrapped in, to hold the lamp when inserting it into a fixture. Be sure to remove all coverings from the lamp before turning it on. If a lamp has been touched, wipe off the surface with a clean cloth slightly moistened with a mild detergent or with lens-cleaning fluid.

Simple quartz lamp fixtures are commonly sold for use with Super-8 motion-picture cameras. These units may have a High/Low switch but no other controls. For color film, the lamps should be used on High; the Low power will produce an orange cast.

Slightly more sophisticated are the small quartz lights used by professionals for location work. These often come with barndoors, focus control for adjusting the beam from flood to spot, provisions for adding filters, diffusers, color gelatins. For example, by inserting a blue-gold dichroic glass filter one can change the tungsten light to "daylight." This would be useful when you wish to combine sunlight from a window with supplemental light: The dichroic-filtered tungsten light will blend with sunlight to

Portability is the great advantage of on-camera electronic flash units like the one shown here. Some flash heads can pivot on their mounts for better control over the coverage of the light.

produce good results on daylight-balanced film.

To summarize: Professional tungsten-halogen quartz lamp equipment is tougher, better able to stand constant moving, and easier to adjust than photoflood equipment. If you want to use a constant-light source, professional lamps with associated fixtures, stands, and other accessories are the best choice; however, they do cost two or more times as much as photoflood equipment.

Electronic flash

Electronic flash has so many advantages that, even if you prefer sunlight or tungsten lamps, it would be wise to have a portable electronic flash for travel, garden shows, and cloudy weather. Modern electronic flash units are versatile and come in a range of sizes from tiny 3-inch hot-shoe units to rather heavy models that accept several power sources.

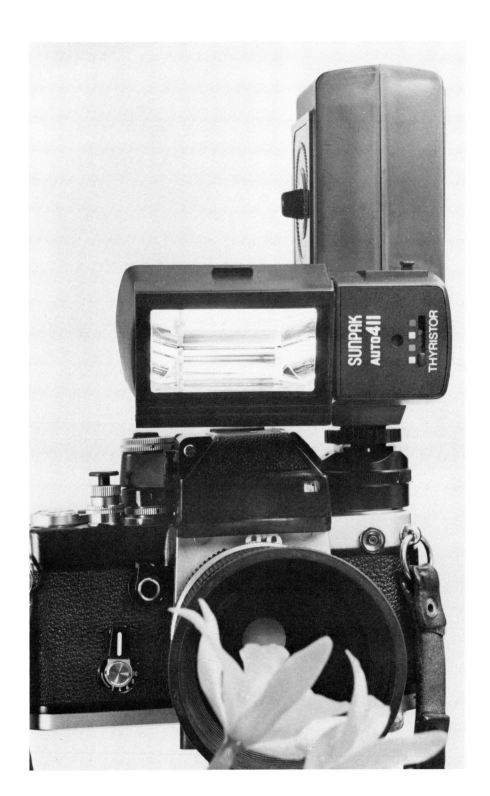

Light and Lighting

The small-to-medium sized units that can be carried easily in a shoulder bag are the most practical for travel and for occasional use at home. Many models incorporate a light sensor for automatic operation. In the automatic mode, the sensor eye "reads" the quantity of light *reflected back* from the subject and adjusts the flash output. When a subject is distant or dark, the sensor in the fraction of a second senses less reflected light and the circuitry permits more flash power to be released; the opposite happens for nearby or bright subjects.

More details on the use of flash units are given in the next chapter under the heading, *Flash Outdoors,* and ring lights were described in Chapter 5 in connection with close-up work. What follows is a quick review of some of the things the new small flash units can do. This is a fast-growing area, and each year sees units that are more compact, more capable, easier to use, and relatively more economical in price.

Many units now offer a choice of power outputs, thus permitting you to choose different *f*-stops and so change the depth of field. Dials on the more sophisticated units show the range of *f*-stops possible at various settings, plus the near-to-far distance over which the automatic mode will

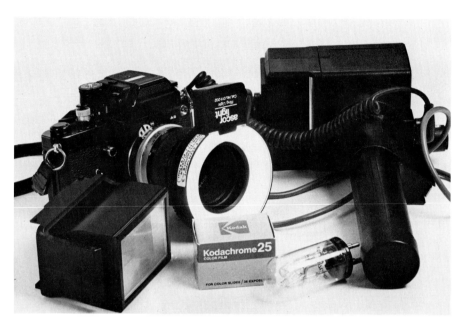

The Ascorlight 1600 II has an interchangeable head that accepts a ring light (shown on camera) or a bare bulb (right foreground). The regular head (left foreground) turns and tilts for use as bounce lighting. Like many such portable devices, this electronic unit works either on battery or from AC via an adapter.

provide average exposures. Automatic systems may work well for average scenes but less so if the sensor (electric eye) reads a large expanse of black or of white, or something closer or farther away than the subject you want to have correctly lighted. This is the same problem any exposure meter has when judging a subject that is very dark or very light or has a bright or a dark background. Bracketing techniques can overcome these situations, and are usually explained in the operating manual provided by the manufacturer.

Some of the newest electronic flash units offer remote sensors, which can be placed so as to read a limited area. Without a remote sensor you can still help the built-in flash by using care that the sensor is pointed directly at the most important subjects. It may help to remove the flash from the camera or bracket and hold it above and to one side of the camera with the sensor pointing toward the main subject. This will keep objects closest to the flash from getting too much light (being overexposed) and throw more light on those farthest away (preventing underexposure.)

"Dedicated" flash units

Several 35 mm camera models have electronic flash units matched specifically to that camera's automatic circuitry. These are called *dedicated* units, since they are made by the camera's manufacturer to complement features in that particular model. For example, the dedicated unit usually has a circuit that will set the correct shutter speed for electronic flash synchronization. Popular 35 mm SLRs have shutters at the focal plane, within the camera body, which must be set for medium-to-slow speeds when used with electronic flash. (Generally this speed is marked by a red "X" on the shutter-speed dial.) At faster shutter speeds, the electronic flash may go off while the focal-plane shutter curtain is only partly open, resulting in part or all of the frame's being black. With a dedicated unit, the correct shutter speed is set automatically when the unit is attached, and the photographer has one thing less to remember.

A *disadvantage* of most dedicated units is that they are on-camera hot-shoe designs, made to be attached directly to the camera body. Among their *advantages*: They are suitable for many situations, especially medium-close-ups, and they can be used to trigger larger units or accessory electronic flashes positioned to light the subject from other angles.

"Slave" flash

Inexpensive electronic flash triggers, called *slave triggers*, can be attached to the sync cord or socket of an electronic flash to provide wireless synchronization with the flash on or connected to your camera. If you wish to have three flash units—a main light, a background or backlight, and a fill-light—you need plug only *one* into your camera's X-synchronization socket. When you press the shutter release you set off the on-camera flash, and the "slave" triggers will fire the other two units. Slave triggers come as accessories for smaller battery-powered electronic flash units but are often part of the original circuitry in larger studio electronic units.

How a photographer chooses to expose a scene is often a matter of personal interpretation. Here, the almost-white leaves contrast powerfully with the deep shadows, as the lone human figure does with the rigid architecture.

Exposure and Metering

To determine an average exposure with reflected light meters, either those in the camera or those held in the hand, use a test card of a neutral gray color.

Neutral-gray card

Kodak offers stiff gray cards with one side having a reflectance of 18 percent (gray side) and the other, a 90 percent reflectance (white finish). Detailed instructions for use are supplied with the cards.

The basic use of the gray card is simple: By placing the card in the subject's position and then measuring the light reflected off the card, you can find the average exposure in which black will look black, whites white, and medium-reflectance subjects in between will be perfectly exposed. Since in a very contrasty situation the film cannot render the whole range of brightness from deep black to stark white, you must some-

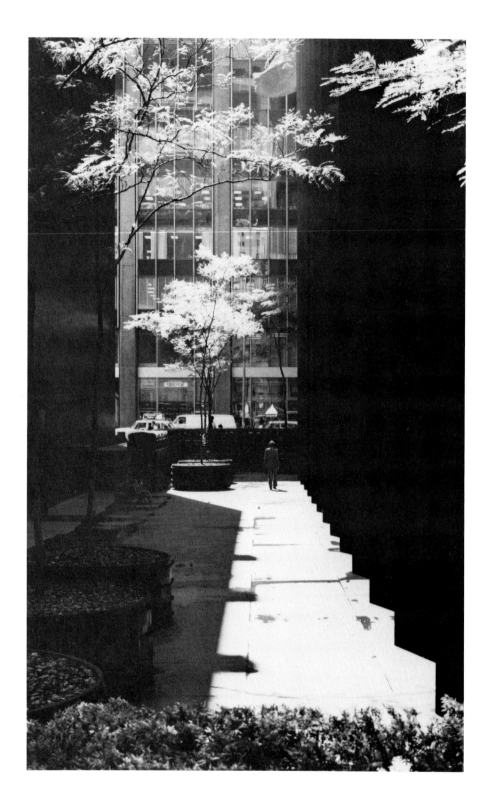

times compromise, adjust the exposure to get the most suitable rendition of your featured subject while letting other parts of the composition come out darker or lighter than they look in life.

With experience you will learn how much more exposure to give very dark subjects, and how much less to give very bright subjects. There is no perfect scientifically precise exposure because each photographer's goals influence what each exposure should look like: You are creating a photograph to capture a vision, perhaps to convey a feeling about a plant or a garden—not just making an average exposure of an average subject. In black-and-white photography you may choose to retain detail in the shadow areas or to keep detail in the bright highlights (white areas), but the film cannot do both. It simply cannot "see" the extreme range the human eye can perceive. In between these extremes is an average exposure—which the gray card and good metering techniques provide.

You may ask, "Why 18 percent gray?" The answer is simple: Film-speed ratings (whether the numbers you use are labeled ISO, ASA, or DIN) are based on scientifically designed scales that determine the minimum exposure needed to yield an excellent negative or transparency. Sensitivity to light determines this number. Films that are highly sensitive get a high rating (such as ASA 400); films with low sensitivity have a low number (such as ASA 25). All these ratings are carefully worked out on the basis of *average subjects*; that is, those that reflect an average amount of light. Measurements of landscapes, human skins, and various colors in mixed compositions led finally to acceptance of 18 percent reflectance of light as the guide for the average measurement. For this reason, neutral gray test cards are also often called "18-percent-gray cards."

Exposure meters built into cameras give *reflected-light* readings: The meter measures light that reflects from, or bounces off, the subject, then suggests the correct exposure. *Hand-held* (off-camera) *meters* offer two systems of light measurement: of reflected light, as just described, or of incident light, the light that is all around the subject and falls upon it.

Incident-light metering

Incident metering measures the light *falling on the subject.* A light-collecting dome measures the quantity of light at the subject's position, then the meter suggests the correct average exposure. To make an incident-light measurement, hold the meter at the subject position—directly over or in front of or beside the subject—with the light-collecting cell pointing back *toward the camera* position.

This system provides an average exposure not influenced by the subject's own brightness. Photographers often vary the suggested average exposure slightly, according to the results *they* want, not just what the meter tells them.

Light and Lighting

Reflected-light metering

Reflected-light readings are directly influenced by the brightnes of the subject. Bright whites will cause the meter to suggest an exposure that is actually too little for rendering a pure white, and the reverse occurs when a reflected-light meter measures a deep black subject. Thus, at times reflected-light readings are likely to produce whites that are too gray and blacks that are less than rich. This is where use of the gray card will help. Focus and compose, then place the gray card directly in front of the subject. Set the camera when the built-in meter is *reading the gray card*, or take your hand-held meter reading from the card, then set your camera manually. Remove the card and take the photograph. Since the film speeds and developing procedures are based on measurements from average, medium-brightness subjects (18 percent reflectance, like neutral gray), the results will then usually be good.

An exposure determined by a reflected-light reading from a gray card will usually match an incident-light reading within half an *f*-stop, but automatic cameras that meter the light and then determine the "correct" exposure may give less than satisfactory results when subjects vary from average brightness. This is why it is better to take flower portraits with a camera that offers full manual control.

Remember that both reflected-light and incident-light readings are only guides, and they may have to be varied according to your taste. Outdoors in direct sun, an average subject often needs half to one stop more exposure than that indicated by the gray-card reading if you want to keep detail in dark areas (as in landscapes). For close-ups with diffuse sun, the gray-card reading is usually the best for average subjects.

Adjusting readings

In general, *negative* films, both for black-and-white and for color prints, can be given slightly *more* exposure than the incident reading or gray card measurements suggest if you want full detail in the shadows. Negative film has a wider range of acceptance (greater "latitude") than transparency or slide film.

For *slide* films such as Kodachrome, Fujichrome, Agfachrome, or Ektachrome one can give slightly *less* exposure than indicated by the gray card or incident-light readings—one half to two thirds less—to obtain greater detail in highlights and more saturated color.

If you are making slides only for projection, you can expose to get the contrast you prefer. For publication in color, however, the transparencies

Exposing a backlit subject can be tricky. Remember that you want to see detail in the shadows, and so you must compensate for the extra light reaching the lens by opening up one *f*-stop or more. Many foliage plants like these floating Philippine examples look best with side- or backlighting.

should have a more limited contrast range. A printer will do best with color reproduction when the original slides have a 3:1 or a 4:1 ratio between the brightest portion that must show some detail and the darkest portion in which detail is needed. No printing process, whether for photographic enlargements, or for reproduction printing in ink, can capture the extreme range, from dark to light, that a transparency can register. When a slide is printed, for enlargements or in a publication, the shadows become darker and highlights

have less detail, especially if the bright portions were slightly overexposed on the original slide.

To produce highlights with adequate detail in slide films, favor the lighter portions of a scene when using a reflectance reading like that provided by built-in behind-the-lens camera meters. This is why reflectors to "fill in" deep shadows are so useful

in plant photography: By bouncing light into the shadows one can give less exposure, and thus the lighter portions of the slide will have better detail. If highlights are overexposed, they have no detail.

Light and Lighting

When you want to photograph a scene of extreme contrast, such as the one here, consider carefully how you want the tones to be rendered. For example, do you want the shadows to appear in your black-and-white print as dark black, or do you want to see detail in them? In this shot of a papaya tree against a wood and bamboo house in Sumatra, the photographer chose an exposure long enough to show the pattern of the woven bamboo in the highlights but not so long as to lose detail in the shadows by overexposure.

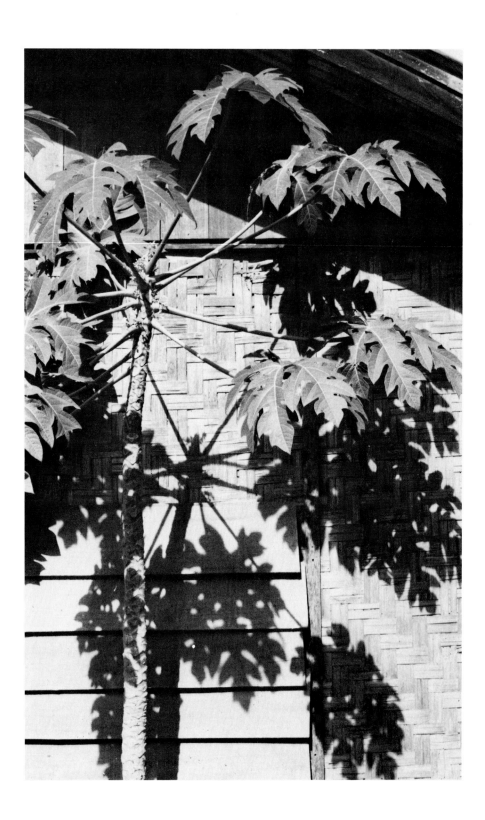

For negative color films, the metering should favor the shadows in order to retain detail. Negative films have enough latitude to hold detail in the highlights at the same time. The ideal situation for the best prints is to use a middle exposure between the brightest and the darkest; here again the neutral-gray card and incident-light metering techniques prove useful.

To determine how you will use meter readings, keep notes on how you determined exposure and on any variations you made from meter readings, study the results, then decide your preferences for future situations. If you put your test exposures into an album along with your notes (written on slide mounts or next to the prints) you will have a reference collection to remind yourself of methods that were effective and mistakes to avoid.

Complex Lighting: An Example

When indoor plants are photographed at a window, keep the window out of the viewfinder. If the window is at your side or your back, it will present no problem. If you wish to *include* an outside view in the same frame with the indoor plants and have it all perfectly exposed, however, you must *add enough light* indoors to balance that out-of-doors. Follow the procedure below.

1. Select an overcast day if possible, so that the contrast between indoors and outdoors will be as small as possible.
2. Meter for the correct exposure *outside*, looking out through the window. It may be something like $f/8$ at 1/60 sec. with ASA 25/15 DIN film.
3. Add enough *indoor* light (using electronic flash, blue flashbulb, or reflectors) to photograph the indoor plants at the same 1/60 sec. $f/8$ exposure. Giving *more* light indoors will make the outside slightly darker, while *too little* light indoors will cause the plants to be seen as silhouettes.

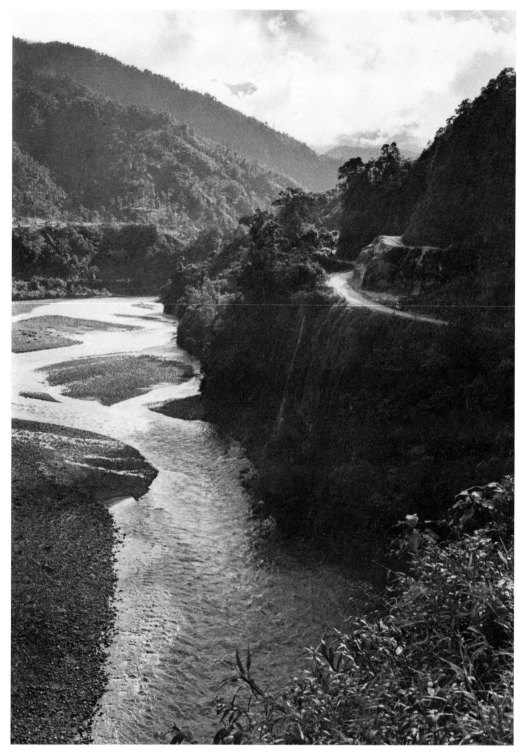

The inclusion of foliage in the foreground and the use of the smallest aperture for maximum depth of field help give the viewer a sense of dimension in this Ecuador landscape. The curve of the river, too, leads the eye back into the picture. If the photographer had not chosen the time of day when the angled light turned the river silver, however, the photograph would have lacked the contrast that gives it life. Habitat shots are important to any documentary work on flora of a region, especially when signs of the climate (here, clouds over the Andes) are included.

7

Outdoor Techniques

Photography outdoors requires different techniques from indoor work because you have less control of the environment. Weather and light conditions are so variable that each situation must be evaluated individually. For example, photography on a sunny June day with no breeze is relatively easy, but on an overcast day with wind one has more difficulty getting adequate sharpness and depth of field. The time of day will also have an influence.

Time of Day

Early in the morning and late in the afternoon, daylight is redder ("warmer") than it is from midmorning to midafternoon. Many people like the effect this warmer light has on orange or red flowers, making their colors vibrant and rich. Blue flowers will be too pink for most tastes, however, and pink flowers will look orange in the color photographs.

Our eyes adjust to the changing color, and (except for very early or late in the day, when the sun itself actually looks orange) we tend to see the colors we expect. Color film, being a chemical process, is constant in the way it renders color and will therefore show foliage and flowers photographed when the sun is low in the sky as warmer—that is, redder. Such an effect is often desirable for capturing dramatic colors in fall foliage or masses of bedding plants, such as wax begonias or geraniums, especially in front of wooden or stone buildings, but not if accurately colored portraits of plants are wanted.

When you desire the truest-to-life color, plan your daylight color photography for between midmorning and midafternoon. Even full harsh sun at noon can be useful for close-ups if it is diffused or bounced (as detailed in Chapter 6). Experience will teach the observant photographer a lot.

Although working outdoors in bad weather is difficult, it can reward you with wonderfully evocative photographs. The monsoon rain in this photograph of a home in Luzon, Philippines, complements the lush foliage.

Corrective filters

Color-correction filters can be used to make the warm early morning and later afternoon sun appear less red on color film. For example, a light blue (No. 82A or similar) will make photos "cooler" in tone, while if you desire to "warm" the midday sun to enhance orange or red subjects, a light pink (No. 81C or similar) filter will eliminate some blue. Skylight filters also have a slight warming effect, cutting some of the excessive blue from light from the open sky and producing a more natural looking tonality in a slide or color print (as was mentioned in Chapter 5).

Flash Outdoors

When the light is poor or you wish to get maximum depth of field for close-ups, an electronic flash is useful. At times you may wish to fill in deep shadows with flash, yet base most of the exposure on available light. This technique is called *fill flash*.

Modern 35 mm SLRs have focal-plane shutters, which will synchronize with electronic flash only at medium-to-slow shutter speeds (usually 1/60 sec., but some at 1/125 sec. or 1/80 sec.). If you are using a fast film in bright light outdoors, this means an electronic flash will be difficult to use because the shutter speeds must be faster than 1/125 sec. One way around this is to use neutral-density filters, which cut down the amount of light reaching the film and thus permit slower shutter speeds. If you plan to use fill flash, select a medium or a slow film that will allow outdoor exposures at the *f*-stop you want to use and the shutter speed at which your camera synchronizes with flash.

The newer portable electronic flash units have a power ratio control that lets you cut the output from full power down to as little as 1/32 power. This lets you use the units as fill flash. It is also helpful when working at close-up range.

Sunlight plus flash can create an interesting effect. If the sun is bright enough to give an image at the shutter speed and *f*-stop you select for electronic flash, there is the possibility of having a double image on the film. This is the result of the sunlight's providing one exposure while the electronic flash gives another. When subjects are moving the image is especially odd, because it looks like a

partly transparent double, or "ghost," image: The sunlight registered the *moving* subject at 1/60 sec. (or whatever the flash sync speed is for your camera), while the electronic flash *froze* the image at a much faster speed.

The effect can be used to express motion. For example, in a field of wildflowers you could take an electronic flash exposure on a windy day with Kodachrome 25 of *f*/11 at 1/60 sec. The flowers close to the lens would show lots of blur because on the film they are larger than the distant blooms, although all the foliage and flowers will be somewhat blurry

A portable flash unit would have come in handy for this on-site photograph of *Rafflesia arnoldi*, the largest flower in the world; shadows produced by overhanging vegetation in the Sumatra jungle distract from the subject. Yet the dappled natural lighting is appropriate: *Rafflesia* is a parasite depending on the shadow-casting vines above.

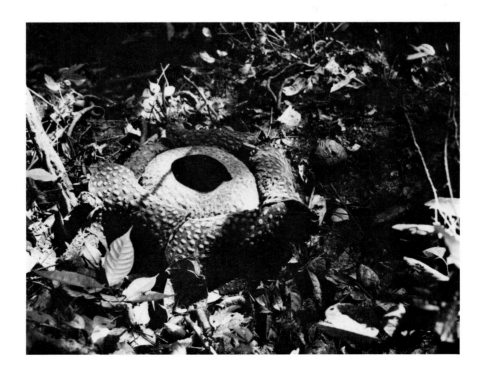

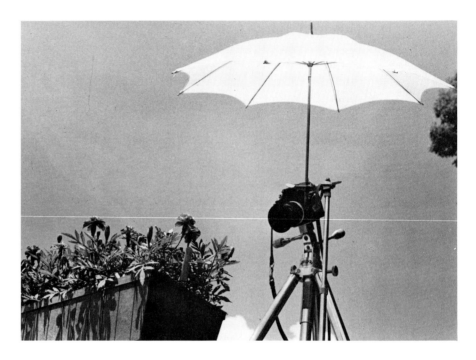

A white cloth umbrella clamped to a portable light stand makes an excellent camera shade on a sunny day. The same umbrella can be used to diffuse direct sun for soft lighting on outdoor subjects.

from their motion. To this effect, the electronic flash will add a sharp, frozen picture; most portable flash units give an effective exposure of at least 1/500 sec., even faster in automatic mode. This technique is fine for impressionist artistic views but is not the way to proceed for scientific records, which should be sharply detailed.

A single electronic flash mounted on the camera can produce bright, crisp, pleasing photographs of plants outdoors. Moving the flash off to one side and filling in the other side shadows with a reflector produces more interesting lighting, best for showing texture. Relatively flat subjects, be they daisies or autumn leaves, may look equally pleasing with direct flash. The way to use flash depends on what you desire (review Chapter 6).

Regardless of the artistic applications of the light, choose the film according to the brightness of the flash and the lens opening you prefer. Outdoors electronic flash exposures based on flash alone will have dark backgrounds. At night the background will usually be black, thus looking dramatic for correctly exposed subjects.

Fast shutter with electronic flash. Cameras with leaf shutters, such as some 2¼-square or larger formats and many twin-lens-reflex designs, will synchronize with electronic flash at much faster shutter speeds than the popular 35 mm SLRs (check individual instruction books for details). Leaf shutters open fully, even at fast speeds, and therefore will capture the short burst of light from electronic flash.

Flashbulbs with focal-plane shutters. Most modern 35 mm SLR cameras with focal-plane shutters will synchronize with the larger No. 6 and No. 26 size flashbulbs, but at lower guide numbers and at slower speeds than cameras with leaf shutters. Using flashbulbs of this size becomes expensive and time-consuming if you need more than an occasional flash, but the possibility is there if you ever need it. Remember that daylight film will need blue bulbs, and read the guide-number instructions.

In the long run, a *reflector* is often easier and more precise to use than fill flash is.

Left: Lightweight Featherflex makes an excellent and highly portable reflector for field work. Here the author uses a sheet of the reflector foil to fill in front detail on backlighted bougainvillia flowers. He is using a 55 mm macro lens with a lens shade to protect against flare. Photograph by Sompong.

Right: Reflectasol opened flat forms a reflector to fill in shadow detail in this clump of *Colchicum* 'Waterlily.' At right center, the white side of a Kodak Gray Card bounces in some additional fill light. In the final view, only the flowers will show, framed against the fallen oak leaves.

Reflectors

Before resorting to flash outdoors just to fill in shadows, experiment with efficient reflectors. A reflector is easier to handle than flash, and you can judge the effect before taking the photograph. A mirror-surfaced Mylar reflector can throw a strong, direct beam of sunlight into a shaded area in such a way that at least small subjects can be illuminated. (Review Chapter 7.)

Outdoors, especially in bright sunlight where you will be likely to have great depth of field, be sure to check backgrounds. Here a strictly sculptured evergreen tropical tree at the Royal Palace in Bangkok becomes confused with a window behind it. The photograph would have been more effective if the photographer had moved so that the tree was silhouetted against the wall.

Coping With Wind

Plants blowing in the wind will come out blurry unless photographed at a fast shutter speed or with flash. If you decide not to use flash, you can cope with wind by adjusting shutter speed.

If you expect the wind to be strong, select a film that is fast enough to permit shutter speed of 1/125 sec. to 1/500 sec., depending upon the motion you want to stop. Distance views where only tree branches must be rendered sharp usually look fine at 1/125 sec. In very windy locations, 1/250 sec. is better. In close-ups, though, even the slightest motion will reduce sharpness because the subjects are seen so much larger.

When speeds of 1/250 sec. to 1/500 sec. are suitable for your close-up work, use them; but if you want good depth of field you will need a small lens opening, and this will limit the speed you can use. When this happens, try to control the subject's motion by using a barrier to the wind.

Clear plastic panels or stiff three-sided plastic screens are useful as wind barriers for small subjects. The light can pass through and, with care to avoid reflections, you can also include the clear plastic or glass within the frame of view; if it is a foot or so behind the subject it will not show in the pictures.

When photographing a panoramic garden scene, coping with the wind can be a challenge. You want to use a shutter speed that is fast enough to freeze the motion of the leaves, yet you need a lens opening small enough to provide great depth of field. Notice in this photograph of a Hawaiian orchid and bromeliad garden that both the leaves in the very near foreground and the distant mountains are in focus.

When light is mainly from overhead or behind, you can use stiff cardboard or colored mat board to reduce the effect of breezes on your subject. Often breezes come in gusts followed by calm periods. If you have time to wait for these calm periods, it is possible to use a slow shutter speed—1/60 sec. or even 1/30 sec.; but this takes patience.

Hyperfocal Distance

You may find the term *hyperfocal distance* in your camera instruction book. This term refers to the distance from the film plane to the nearest point of acceptable sharpness, extending to infinity. It varies with the aperture and with the lens. To determine the hyperfocal distance of any lens, first select the lens opening, then set the focus at infinity. Now, look at the scale on the lens barrel and read the distance opposite the mark for your lens opening. Turn the focusing ring until this distance is opposite the focus pointer. Your lens is now at its hyperfocal distance for that aperture. As an example, for a 50 mm lens on a 35 mm camera at an aperture of $f/8$, the hyperfocal distance is 9 m (30 ft). Focus at 9 m (30 ft) and, with this lens opening of $f/8$, everything from 4.6 m

Sometimes a single flower can suggest a whole environment. The photograph at right shows a hibiscus in a garden in Kuatan, Malaysia. Although only the flower is in focus, exotic foliage is in evidence in the background (lightened by use of a green filter).

(15 ft) away from the camera to infinity (as far as you can see) will look acceptably sharp. Thus, if you wish to work fast without having to focus between each photo but still achieve an acceptable zone of sharpness, the hyperfocal distance method will be useful.

Also, remember that depth of field increases as the lens opening decreases. For example, with a 50 mm lens on a 35 mm camera set at $f/16$, you can adjust the focus to 4.6 m (15 ft)—the hyperfocal distance—and expect that everything from about 2.4 m (8 ft) to infinity will look sharp.

Using hyperfocal distance as a guide for adjusting focus is also useful in landscape work where you wish maximum sharpness of both nearby subjects and a distant feature. Always use depth of field preview to approve the effect before shooting.

Gardens Around the World

City plants

Cities are sometimes exciting, sometimes uncomfortable, places, yet the most crowded metropolis will have picturesque plants somewhere. In New York City, long-lived plants such as trees must be sturdy enough to survive an unnatural environment of concrete mulch, artificial temperature modifications, extra light or too much shade, and, of course, polluted air. In cities where streets are cleaner or the air circulation is better, plants live an easier life. In the tropics, cities often rely on plantings for their

The stark vertical lines of city skyscrapers contrast with the random angles and curves of the rare urban tree. When visiting cities, keep an eye out for poignant or amusing scenes such as this one, which includes New York City's Gulf and Western building and a fruit-bearing crab apple tree.

charm, as in Singapore and Hong Kong. Photographing city plants presents a challenge and is a project worth doing over a period of years.

City plants are related directly to buildings and to people. Choosing how you will show this relationship is a creative, rewarding task. Telephoto lenses will compress perspective, make trees seem closer to buildings. Wide-angle lenses will deepen perspective, making the smallest green spot look like an expansive oasis.

Seasonal displays of flowering plants bring color to cities all around the world. Rockefeller Center in New York City is the site of a continually changing display, for example: Sometimes flowering bromeliads fill the center's rectangular Channel Gardens beds between Fifth Avenue and the famous skating rink. In the summertime, begonias may decorate bubbling fountains where office workers come to enjoy their lunch on sunny days. In many European cities, annuals decorate street planters and even pots on lamp posts and traffic islands offer living color worth including in travel photos, showing how plants bring sparkle to what might otherwise be only stone and congestion.

Botanical gardens give plant photographers a year-round opportunity to shoot both close-ups and garden photographs. In this case, rare cacti were photographed with a 20 mm lens at the New York Botanical Garden.

The great gardens:
Public, private, commercial

Opportunities for plant photographers are found in botanic gardens and estates where visitors are welcome, and in public gardens where great care is taken to produce exciting plantings and seasonal exhibitions. State tourist offices can supply information about sites and visiting hours. A useful listing of botanical gardens, open estates, and university gardens is found in the *Directory of American*

Horticulture, published by the American Horticultural Society, Mount Vernon, VA 22121.

The United States National Arboretum in Washington, DC 20002, has several flower shows and special displays during the year. The rare bonsai collection is open daily from 10 A.M. until 5 P.M.

Commercial producers of flowers, too, can provide the plant photographer with a chance to shoot exotic or out-of-season specimens. Here the photographer caught a woman at work packing orchids for shipment from a Thai orchid range.

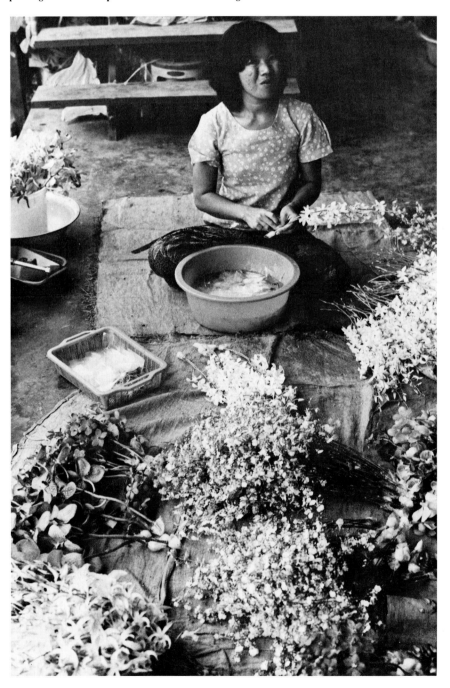

A few other major gardens where photography is permitted and visitors are welcome include the following:

Brooklyn Botanic Garden, Brooklyn, NY 11225

Chicago Botanic Garden, Glencoe, IL 60022

Denver Botanic Gardens, Denver, CO 80206

Fairchild Tropical Garden, Coconut Grove, FL 33133

Foster Botanic Garden, Honolulu, HI 96817

Garden Center of Greater Cleveland, Cleveland, OH 44106

Huntington Botanical Gardens, San Marino, CA 91108

Longwood Gardens, Kennett Square, PA 19348

Los Angeles State and County Arboretum, Arcadia, CA 91006

Marie Selby Botanical Garden, Sarasota, FL 33577

Missouri Botanical Garden, St. Louis, MO 63110

New York Botanical Garden, The Bronx, New York, NY 10458

St. George Village Botanical Garden, Frederiksted, St. Croix, U.S. Virgin Islands 00840

Stroll Garden of the Hammond Museum, North Salem, NY 10560.

Write to the gardens directly for details about visiting hours and dates for special displays. Some gardens are closed certain times of the year; others have big conservatories where tropical plants can be seen even in the cold weather; some offer short courses on plant photography.

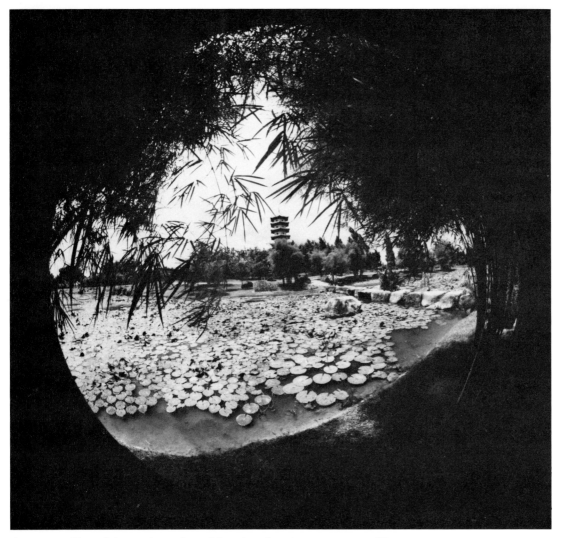

An extreme-wide-angle lens, such as an 8 mm fisheye, is perfect when you want to combine sky, ground, and an important central object in an unusual composition. This view includes a water lily pond, bamboo plants, stepping-stones, and a dramatic tower at a Chinese garden in Singapore.

The national and state parks are not listed in this book. These are of course ideal for wildflower, forest, and landscape photography; but even the most enthusiastic plant photographer must limit ambitions, and so this book stays within the "garden" category.

Besides institutions and estates, many commercial growers permit customers to photograph plants in sales and display gardens. Other opportunities for photographing well-grown plants occur at meetings of plant societies. Remember that in public places you may be asked not to use a tripod; so be prepared with fast film or portable flash.

In other countries, great gardens are important tourist attractions, and so you can find out about them from the individual national tourist offices, as well from well-informed travel agents.

The use of trees and rocks to frame a bridge creates a pleasing balance in this study of a Japanese garden in Singapore.

Among the more extensive and spectacular public gardens around the world, some favorites are:

Alhambra Palace and Generalife Gardens, Granada, Spain

Bogor Botanic Gardens (near Jakarta), Java, Indonesia

Palmengarten (Palm Garden), Frankfurt-am-Main, West Germany

Hope Botanic Gardens, near Kingston, Jamaica

Meiji Jingu Shrine and Gardens, Tokyo, Japan

Montreal Botanical Gardens, Montreal, P.Q., Canada

Penang Botanic Gardens, Penang, Malaysia

Rio Botanic Garden, Rio de Janeiro, Brazil

Royal Botanic Gardens, Peradeniya (near Kandy), Sri Lanka

Royal Horticultural Society Garden at Wisley, Woking, Surrey, England

Singapore Botanic Gardens, Singapore. On Singapore Island there are Chinese and Japanese gardens in Jurong and a private display at Mandai Orchid Gardens, where visitors are welcome; all are worth seeing for both exciting landscapes and also unusual flowers for close-ups.

Versailles Palace Gardens near Paris, France.

Above: Even a mundane scene becomes pictorial when thought is given to composition. By choosing an elevated angle of view and looking diagonally along, rather than straight at, the rows of cultivated plants, the photographer has presented a striking geometric pattern that reinforces the active stance of the gardener.

Right: Inclusion of the Tamil women picking the crop that forms the basis of Sri Lanka's highland economy creates narrative interest in a record shot of well-pruned tea shrubs.

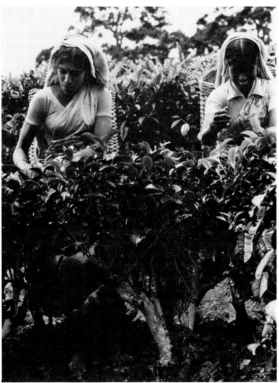

Plants can add significantly to travel pictures. Here, both the extreme angle of view and the frame of dark foliage dramatize this photograph of a colossal Buddha on a hill in Thailand. Sidelighting gives shape to the sculpture, while the trees indicate its size.

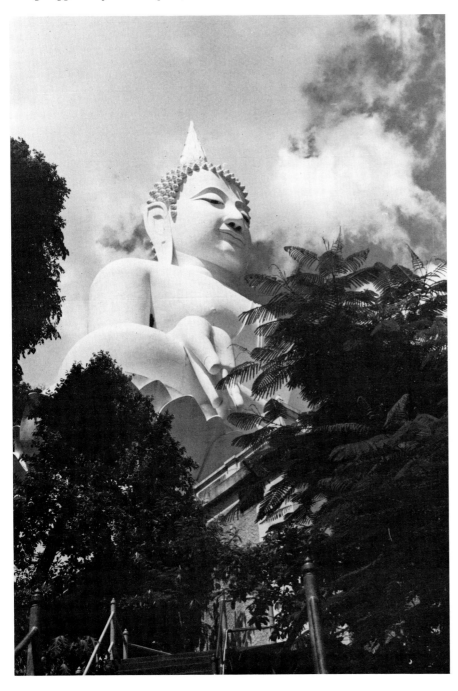

When you are interested in some specific type of plant, such as succulents, orchids, bromeliads, gesneriads, contact the society specializing in those plants for information about members and commercial growers in other countries. Gardeners everywhere are usually eager to share their enthusiasm and will welcome your photographic visit. Plant society international conventions are often planned to accommodate international visitors, and tours of interesting gardens and nurseries are usually part of the convention plans. You can find out about these events by reading the society publications listed in Chapter 9.

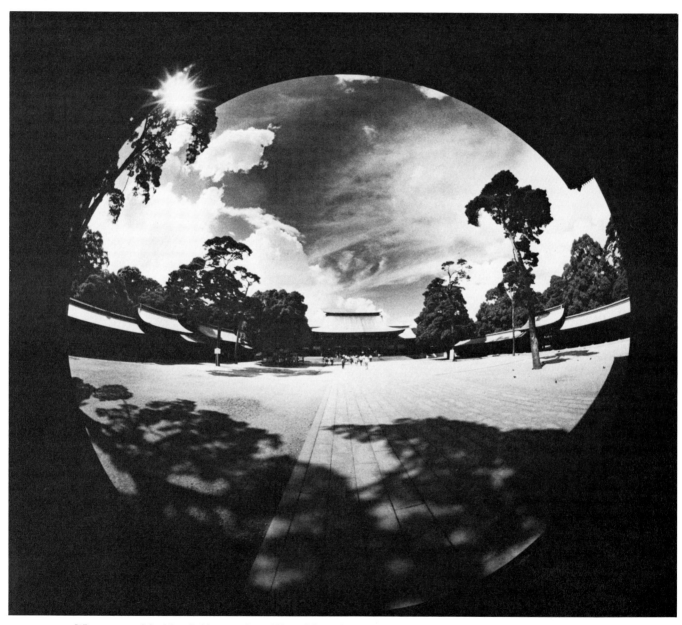

When you travel don't be afraid to experiment! You might not have a chance to return to the same locale. Shoot with a variety of lenses, if you have them. Here, the photographer used an 8 mm fish-eye lens and an orange filter to make the sky appear darker and the clouds more visible at the Meiji Shrine in Tokyo.

Travel Time

When you travel away from home to take photographs, consider the situations likely to be encountered, then choose equipment and film to fit the conditions. For example, although I use Kodachrome 25 for plant portraits at home, it is too slow for field use, except with flash. For travel time I select an ASA 64 film for medium-to-bright light, an ASA 200 for low light such as in forests or jungles, and a few rolls of ASA 400 for available-light photography very early or very late in the day or in bad weather.

Equipment

Carry two cameras, if possible. Having an *extra body* that accepts all your lenses is good insurance for long overseas trips. In addition, one can have color film in it while the other has black-and-white. In an emergency, if only one camera is working use color film because it can be converted to black-and-white later, if necessary.

Take the lenses you need, no others. If you do not plan on photographing wide views, then leave wide-angle lenses at home. A *close-focusing zoom lens* is versatile during a trip and can substitute for several different lenses. If you will only be doing a few close-ups, perhaps a set of *screw-in close-up lenses* would be adequate. But do carry extra lens caps, rear lens covers, and camera body caps, as well as an extra skylight filter.

If you plan on doing photography in low light, take a lightweight *tripod.* Even a miniature tripod that can be set on rocks or car hood is better than no support. Carry a flexible *reflector* to fill in shadows.

Small electronic *flash units* are useful if you plan to capture plants in all situations. For international trips, there are models that can be adjusted to match local electrical current and voltage. Batteries for popular brands of electronic flash units are available in large towns, airport shops, and big cities. Pack at least one extra set of batteries for every item of equipment that uses a battery.

Consider your subject before starting to shoot. Try different angles until you find the one most appropriate for the plant at hand. **Here the author photographs a Brazilian** *Neoregelia cruenta,* **which has flowers deep inside the rosette. A shot from above shows the flowers best, while a second shot from the side will reveal the bromeliad's shape.**

Test everything

Several weeks before leaving on a long trip put new batteries in all your cameras, flash units, meters—whatever uses batteries—and take a test roll to be sure everything is working well. Test any new equipment especially thoroughly. Here are some test tips:

Take the type of exposures you expect to encounter. Write important information on labels you can stick to the equipment. Correct exposure is not always obtained by following the manufacturer's directions on flash units. Both dark subjects and macro lenses focused close require a lens opening greater than will be suggested on the flash dials, while white subjects may need less exposure. A test roll and your notes will prepare you for using the equipment efficiently.

Having the equipment checked before travel, then having a few rolls processed, and examining them, could prevent a disaster.

It is also worth reviewing camera functions during your travels after every few rolls. Watch to see that the diaphragm closes and opens correctly, listen for odd shutter noises, watch the shutter work, check that all screws and knobs are tight. Blow out the inside (a rubber ear syringe works very well) to get rid of film chips and dust. If anything mechanical seems wrong, have the camera checked by a qualified repair shop in a major city. Never trust a camera or lens that has been dropped or soaked until it has been evaluated, perhaps repaired, by a qualified technician.

If you will be going through a lot of airport security checks, as happens on a multination trip, pack film in lead-lined bags. Not all security guards are willing to examine luggage by hand, but it does not hurt to request this courtesy. Go through security check stations well in advance of boarding time if you want security personnel to examine your equipment and bags by hand.

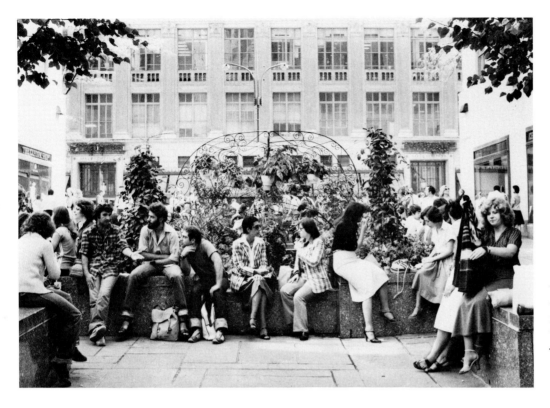

You may want to empasize the use of a garden, as well as the plants in it. Here, a medium-distance shot shows people enjoying the Fifth Avenue end of New York City's Channel Gardens at Rockefeller Center on a summer day.

Seasonal Coordination

You may wish to time your travels so that you arrive on location when specific plants or landscapes are at their best. Remember that in the tropics the climate does change as the result of altitude or of rainy and dry seasons. There are four basic situations to be aware of when planning a tropical trip.

1. Cloud Forests

Here there is almost always some mist. Because of the high altitude (usually over 1220 m, or 4000 ft) temperatures are moderate, with nights often in the 50s F (10–15 C). These moist forests are excellent for year-round photography of epiphytes such as orchids, bromeliads, and ferns.

2. Rain Forests.

These forests get some rain almost every day. They are usually hot and very humid, and have extreme contrasts in light from shade to sun. The Amazon River basin is one example. The traveler must be prepared for rain and sun within minutes of each other. There is little variation in temperature from month to month, but nights are usually cooler than days.

3. Forests With Wet and Dry Seasons

Much of Central America has distinct wet and dry seasons, as do Southeast Asia and India. Visit these areas during the dry months for easier travel, as roads often become flooded during the rainy seasons. A wet season for some areas of the Philippines, such as Luzon, comes in July and August. Torrents of rain during these monsoon seasons make outdoor photography difficult. In Central America, the dry season is usually during the winter and can last for months, making outdoor photography pleasant except for occasional problems with dust and haze from fires.

4. Reversal of Seasons

Remember that the seasons are reversed when you cross the Equator. In the Northern Hemisphere spring comes to the garden in March and April, but in the Southern Hemisphere early spring flowers appear in September and October. If you have the time, you can travel through two springs each year, or enjoy the fall foliage twice each 12 months, by voyaging from one hemisphere to the other.

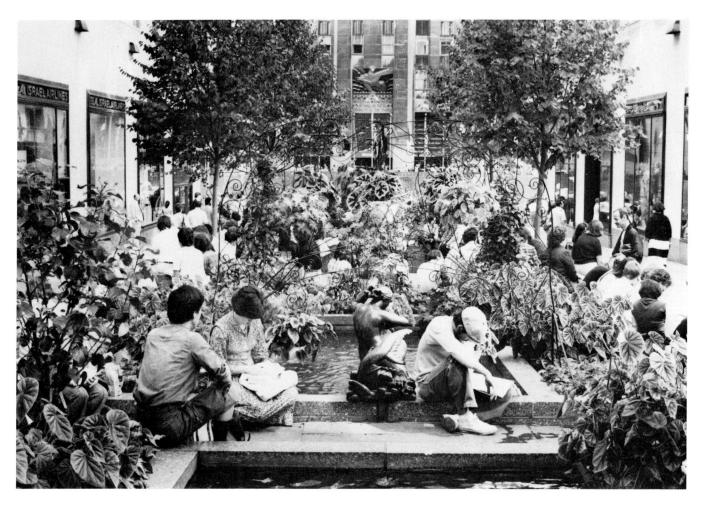

A closer shot of the Channel Gardens shows the plants in more detail. This view is in the opposite direction from that on the previous page and includes one of the Rockefeller Center Art Deco buildings as well as one of the bronze fountains that grace the area.

Flash for travel

Your portable flash will be most useful on dull days, for indoor markets or flower shows, and occasionally to fill in shadows on sunny days outdoors. If you enjoy looking for unusual plants in tropical or woodland habitats, flash is indispensable for optimum quality of color. Although the day may be sunny, little light actually reaches a jungle floor, and forests seldom get more than dappled light.

With a tripod, reflectors, and calm weather you can get satisfactory photos in some situations; but a flash makes the work faster, easier, and sometimes much better when natural light is low and/or diffused. In botanical gardens and greenhouses you may find it difficult to use a tripod; and so a flash can save the day by making slow exposures unnecessary.

Choose your angle carefully with flash exposures, to avoid having reflections off distracting background objects. If you must photograph through glass—for instance, a glass-

Here, the photographer moved in close to the foliage display, focusing attention on the begonias themselves. The displays are changed seasonally. Each of the three photographs in the series accomplishes a different objective. Moving into, away from, and around a subject can reveal aspects you might not have noticed at first.

topped case—remove the flash from the on-camera bracket and hold it higher and to one side, pushed against the glass.

If the sensor in automatic units will "see" anything other than your subject, switch to the manual setting and adjust the lens accordingly; many units have dial calculations that suggest what *f*-stop to use, according to distance from the subject and film speed.

When photographing wildflowers, you may have to spend a few minutes gently clearing away things not wanted in the photo. Some leaves between you and the subject may have to be plucked.

When using an on-camera flash unit, check that the light has a clear path to your subject since obstructions like branches can make distracting shadows. For a flash held near the camera, consider using a small reflector on the opposite side to fill shadows.

Protecting Camera and Film

During travel, equipment is subject to humidity, dust, heat, and shocks. Having a suitable case is the first step in protecting your equipment. Remember never to pack delicate cameras or lenses in a suitcase that gets handled by the airline.

Travel *vibration* and knocks can cause flexible metal battery contacts to lose touch with batteries. If this happens, gently bend the metal contacts back toward each battery.

Corrosion may accumulate on batteries and contacts. Clean off any crust with a dry pencil eraser, then blow the powder out before closing the battery compartment.

In *dusty* or *rainy* locations a tough plastic bag is an inexpensive lightweight protection. For example, photographing shore plants at the beach, or the harvesting of crops such as grain or sugar, means your cameras may get dirty with dust and sand. Keep cameras and lenses inside the plastic bags between uses, and while walking about between shots keep your hand over the lens cap, too. *Blow*—do not *wipe*—dust off lenses and cameras before opening them.

A different problem occurs in humid climates. Equipment taken from an air-conditioned room or car into a warm, humid atmosphere will become covered with condensed moisture. If the sun is out, let it warm your equipment for a few minutes, then gently fan the lens with a piece of paper to help the condensed moisture evaporate.

Once I was driving through monsoon rains in the Philippines, but my car was quite cool, having just come down from a high-altitude cloud forest. Now, metal camera parts retain cool temperatures for a long time. When I opened the car window to take photos of rice fields, both camera and lens were immediately covered with thick condensed moisture. Since the outside air had 100 percent humidity, even fanning and wiping the lens with lens tissue did not help. After 15 minutes I drove on without the photograph. If you take photos through fogged lenses the effect is soft, sometimes pleasantly romantic, but that is no good for documentary photographs.

One solution to the *condensation* problem is to be sure your equipment is at the same temperature as the location where you will take photographs. This is not always possible when you are traveling fast or do not plan to be taking photos until the last minute.

Another solution is a plastic bag. Before leaving a cool room or vehicle, wrap your camera in the plastic bag. Squeeze or suck out as much air as you can, then twist or seal the bag. This will keep much of the condensed moisture off the equipment; but you will still have to wait until the camera and lens have warmed to location temperature before removing the bag.

Be prepared with a soft cloth or lens-cleaning tissues to wipe off the outside of your equipment. If excessive condensation does form, leather cases, straps, and boots will also have to be dried when humidity is constantly high. Waterproofing can help protect leather against fungus and rot in the tropics. In rainy weather, dry out equipment when possible. A portable hair dryer (on the lowest setting and held far enough away to avoid overheating the film) is a good way to dry equipment. Silica gel packs are useful for absorbing excess moisture.

Although mist, rain, and high humidity may cause the most immediate problems, the other extreme— very dry, hot locations—can cause film changes. Avoid leaving cameras and film in cars or other places where temperatures can get very high.

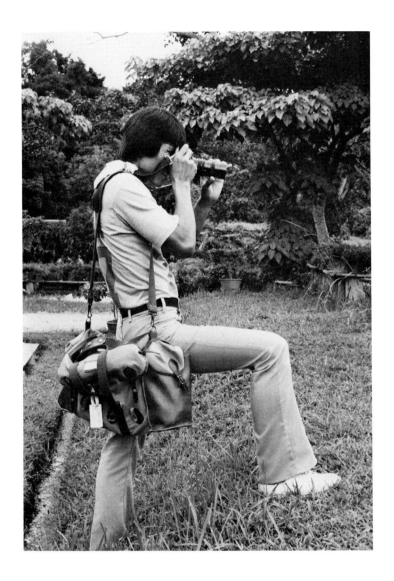

A camera bag is a most important accessory when you are traveling or doing field work. It must be both comfortable to carry and durable. Make sure the strap is wide enough to distribute weight. Easy accessibility to equipment is important, too.

Cases

Your camera will stay in good condition if you keep it in a sturdy case between uses. The least expensive popular case is the ever-ready style frequently purchased with new cameras. This type of case fits snugly over the camera body and lens. Usually the case has two parts: One holds the camera body and has a screw coming through the bottom into the tripod socket; the other is a removable front that protects the lens and camera top. A strap is attached to the camera section, or to the camera body, so that you can carry the camera around your neck.

The ever-ready case is fine for carrying one camera. But once you have an extra lens, a few filters, perhaps another camera body, the ever-ready case may become a nuisance. You will need a larger bag to hold all the equipment.

A shoulder-style bag can hold at least three lenses, filters, a meter, a small flash unit, and a few accessories. It is better to have a slightly larger bag than you might need. Extra space is useful for rolls of film or even support items such as a notebook, map, insect repellent, or a few cleaning supplies.

Sturdy bags come in a great variety of sizes and configurations. Examine

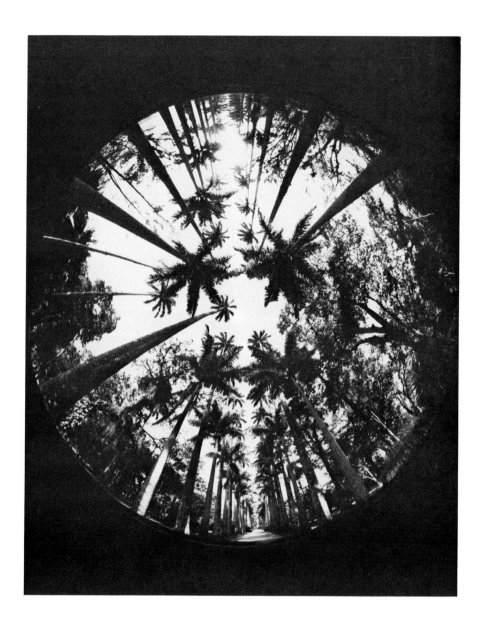

If you own unusual lenses, such as the 8 mm used to photograph this line of royal palms at the Rio Botanic Gardens in Brazil, remember to take them into account when shopping for a camera bag. Look for a bag that will accommodate safely all the equipment you need to take along.

the choices before making a purchase. Some have top openings that fasten with a zipper. Others have tops fastened with heavy-duty clips. These offer quick access, which can be important when one is traveling or taking photos of active events such as harvesting, or processing of food plants, or felling of trees.

Some gadget bags are of soft construction, made of canvas, Cordura nylon, leather, or leatherlike plastic. They yield when stuffed with odd-sized equipment, but they do not provide maximum protection. To keep equipment better cushioned in soft cases, wrap lenses and cameras in air-pocket plastic ("bubble" sheeting) or in padded pouches or snap-top lens cases.

Between hard-sided and completely soft cases are such camera bags as those made of tough waterproof cotton canvas withz a middle layer of foam rubber, leather tops and bottoms, sturdy web strapping for carry handles that continue around the whole case, and a shoulder strap.

Look for these important features in the bag from any supplier:
1. Full wraparound support from heavy-duty straps. Straps that are only sewn onto the top usually tear off.
2. Waterproof material, or material you can treat with a fabric protector to resist water damage.
3. Internal design compatible with your equipment.
4. Convenient access to equipment under the working conditions you expect.

Cases with stiff sides provide maximum protection, especially during location and overseas work. Avoid inexpensive types that have simple sewn-on straps or cheap metal rings that will bend or break. If most of your work is indoors, or somewhere that you can set down a flat case, you

might like the suitcase type. Some come with full foam rubber insides, which you cut to fit your own equipment, or with partitions that can be adjusted as needed.

Tropical considerations

In the tropics, equipment needs special protection against moisture and dust. Some tropical regions have a long dry season during which fields and roads are filled with fine dust that easily penetrates many cases. For short excursions, you can make do with plastic bags as extra protection, then clean the equipment each night. For longer trips you might want a waterproof camera bag, either metal with a rubber gasket seal or the folding plastic type offered by sporting-goods companies.

Nylon Cordura, aluminum, and Fiberglas cases are good choices when you must remain in humid regions. Avoid leather and rubber. To protect the equipment itself, keep a few small pouches or canisters of silica gel inside the cases. (Dry the silica gel in a slow oven or beside a fire every few days to drive out accumulated moisture.) You can get silica gel from sporting-goods dealers if your camera store does not stock it.

Where to Get Detailed Information

Well in advance of your trip, contact the tourist offices of various countries to get specific information about the seasons you plan to visit. This is especially important in some tropical areas, where a country may have a wet season in one region while another section of the same country is in its dry season. Natural boundaries and wind currents, rather than political boundaries, are responsible. Some well-prepared travel agents or air and ship lines, too, can furnish specific details of rainfall and temperatures at various places in the world during any given period.

Be very clear in stating your interest in seeing flowering plants and gardens and taking photographs. Professionally planned tours are usually arranged to visit areas during the most pleasant months, but if your interests are specifically in nature it is wise to plan overseas travel with this in mind. Begin by reading background material on the areas you wish to visit. For Southeast Asia you can send one request to a single office, simply indicating the countries you wish to visit. Write to the Pacific Area Travel Association, 228 Grant Ave., San Francisco, CA 94108, U.S.A., or to the European branch at 52 High Holborn, London, WC1V 6RL, England. The association will forward your request to the countries concerned. Then, after reading the general literature, you may wish to contact the tourist offices of individual countries with detailed questions.

Two photographs taken at the same place can make different statements about a city park. *Above left:* **Taking the photo from a higher angle shows lovely plants and sturdy trees in a busy city setting.** *Above right:* **Choosing a low angle still reveals the buildings, trees, seasonal marigolds, and pigeons but emphasizes a bag of litter.**

Photographs on the Move

You can often get satisfactory photographs from moving vehicles if you remember to use a fast shutter speed and avoid reflections when taking photos through glass, for instance by using a polarizing filter.

Airplanes

Forests and farms look interesting from airplanes, and such views add another dimension to your terrestrial landscapes. The best time to shoot is when your plane is low. With small cameras from 20,000 feet or higher, detail is reduced so much that, except for big mountains and rivers, you might as well wait until the plane descends. Use shutter speeds of 1/500 sec. to 1/2000 sec. and focus on infinity. For black and white, use an orange or red filter. With color film, a skylight or ultraviolet filter will help cut atmospheric haze. Polarizing filters make a clearer view possible by cutting reflections, but most plane windows are made from material that creates a rainbow effect when a polarizing filter is added. This can look nice, but not natural.

Automobiles

In land vehicles, stop when possible, turn off the motor to prevent camera movement, and take photographs through *open* windows. When you cannot stop, increase shutter speed to avoid blur. If the vehicle is moving fast and you have only moderate shutter speed or your film is slow or the light is dull, pan the camera as you take the photo. This is not hard to do. For example, if you are taking a picture of a rubber plantation from a moving bus, point the lens *ahead* of the bus, in the direction you are going. As the bus moves forward, center your viewfinder on the subject and swing the camera toward the back of the bus, keeping the plantation view relatively stationary in the frame. Release the shutter in the middle of the swing (panning motion).

Other vehicles

If you *know* that you will be taking photos from a moving vehicle, choose a fast film and "fast" lenses, those that let enough light reach the film.

Once I was on a launch in Uganda, photographing forest habitats along the upper Nile. Also on the launch was a gentleman with a very expensive 35 mm single-lens reflex fitted with a long telephoto $f/4$ lens. His camera was loaded with Koda-chrome 25 film. This unfortunate fellow, a beginner in photography, had asked the camera store salesperson for "the best color slide film" without saying how or where he intended to use it. Although Kodachrome 25 is excellent film, it is not the best choice for taking telephoto views from a moving launch. Film of ASA 200/24 DIN to ASA 400/27 DIN would have been more appropriate.

In many countries it is common to travel on motorcycles. It is possible to get satisfactory shots while traveling as a passenger on a motorcycle. I have photographed rice fields and coconut plantations this way. It is easy to focus, frame, and pan because there are no windows to get in the way. On the other hand, you must be careful to have a good driver, maintain balance, and use a high shutter speed, especially when the roads are bumpy.

Travel Time

When you're in the field it is especially important to take care in cleaning up plant specimens. You may need to clear away brush and leaves for a good view. Here, the author prepares a begonia species on a mossy rock in the jungles of Sumatra. Photograph by Jiwa Baru.

Horticultural Tours and Visits

Botanical gardens often offer a printed list telling what you may expect to find in bloom each month. Write to the botanical gardens directly, mentioning your specific plant interests. Horticultural organizations frequently sponsor domestic and international tours to sites of outstanding horticultural interest. Such tours are usually led by experts in various fields of natural science. The organizations listed below sponsor such tours and will be pleased to send you details of their future tours.

American Horticultural Society, Inc.
Mount Vernon, VA 22121
 Domestic and foreign trips.

Smithsonian Institution
National Associates Office
Washington, DC 20560
 Domestic and foreign tours for associates of the Smithsonian (open membership).

New York Botanical Garden
Education Department
The Bronx, New York, NY 10458
 Trips concentrate on flora of domestic and exotic areas, gardens, and natural habitats.

Swan Hellenic Cruises
237 Tottenham Court Road
London W1P 0AL, England
 Specialists in flower cruises around the British Isles and the Mediterranean. The cruises are accompanied by professional botanists and other lecturers.

In addition to Swan Hellenic Cruises, you may find other European-based horticultural tours advertised in Garden: The Journal of The Royal Horticultural Society, *which is available in many botanical garden libraries.*

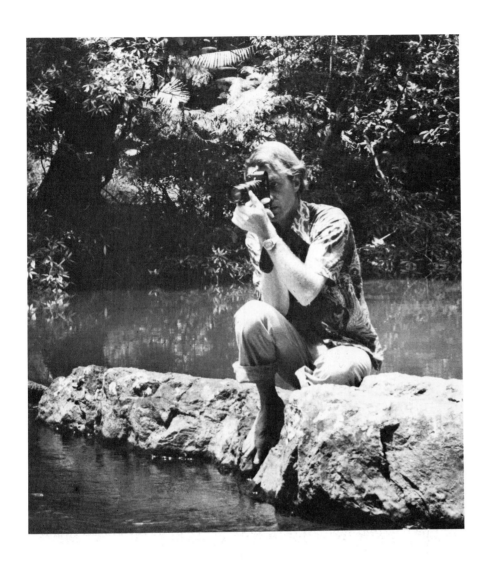

You often need to improvise when traveling. Note how the author uses his body to brace the camera when using a telephoto lens—a tripod is out of the question in this situation. Photograph by Sompong.

Specialized horticultural societies occasionally sponsor trips that concentrate on study of specific genera, such as begonias, bromeliads, or orchids. Information is available directly from the societies. Almost all national plant societies sponsor yearly shows at which prize plants offer excellent opportunities for photographing superior specimens.

Besides trips and study tours, some organizations coordinate visits to specific gardens. In the United States the National Garden Bureau, Inc., offers a folder listing the trial grounds and display gardens for All-America Selections, best visited from May through June in the Deep South, through late August in the Northern states.

The display gardens are excellent places for photographing new annuals and vegetables. To receive a current list of the All-America Selections Trial and Display Gardens, send a self-addressed business size stamped envelope to: National Garden Bureau, Inc., P.O. Box 344, Sycamore, IL 60178.

In Great Britain, visits to historic public and private gardens are coordinated by several organizations. General information can be had from The Royal Horticultural Society, Vincent Square, London SW1P 2PE, or during a visit to the R.H.S. display gardens at Wisley, Woking, Surrey GU23 6QB, where several booklets listing garden visiting dates are offered.

You can also write for information directly to the organizations listed below.

The Organising Secretary of the National Gardens Scheme
(Gardens of England and Wales)
57 Lower Belgrave St.
London SW 1W OLR

Scotland's Gardens Scheme
26 Castle Terrace
Edinburgh EH1 2EL, Scotland

Irish Tourist Board
590 Fifth Ave.
New York, NY 10036
(Free booklet on Irish castles and gardens).

Plant Societies

Among the active plant societies are many that have illustrated publications. Some of the groups also produce color-slide programs for the education and entertainment of members. Plant societies welcome new members and will send membership and publication information. Since many of these groups are run by volunteers, and officers change every year or two, your letter may take a while to be answered. The most up-to-date names and addresses will be found in a recent copy of any of the magazines listed; they are often on display at libraries of local botanical gardens.

The African Violet Society of America
P.O. Box 1326
Knoxville, TN 37901
Has a color illustrated magazine and welcomes color slides for programs and reference: Write to Harvey Stone, Librarian, at 51 Peach Highlands, Marblehead, MA 01945, about slide programs.

The American Begonia Society
6333 West 84th Place
Los Angeles, CA 90045
Has an illustrated magazine, photography section at most begonia shows, slide library. Write to Kathy Brown, membership secretary, at 10692 Bolsa Street # 14, Garden Grove, CA 92643.

The American Gloxinia and Gesneriad Society
8 Kane Industrial Drive
Hudson, MA 01749
Publishes illustrated magazine, sponsors photo section at shows.

The American Horticultural Society
Mount Vernon, VA 22121
Uses professional quality photographs to illustrate articles in color magazine.

The American Orchid Society
84 Sherman Street
Cambridge, MA 02140
Publishes a bulletin and other publications; top-quality photographs are welcome. Many local affiliated societies.

The American Plant Life Society
Box 150
La Jolla, CA 92037
Welcomes black-and-white prints to illustrate readers' articles, mainly about indoor bulbs.

The Bromeliad Society
c/o Victoria Padilla, Editor
647 South Saltair Avenue
Los Angeles, CA 90049
Has color illustrated magazine, welcomes photographs to illustrate readers' articles.

Cactus and Succulent Society of America
Box 167
Reseda, CA 91335
Has a well-illustrated magazine, welcomes articles from readers, illustrated with photographs.

Indoor Light Gardening Society of America
c/o Horticultural Society of New York
128 West 58th Street
New York, NY 10019
Has illustrated magazine and slide library.

International Carnivorous Plant Society
The Fullerton Arboretum
California State University
Fullerton, CA 92634
Has a color illustrated magazine devoted to the study and culture of insectivorous plants. Welcomes articles and photographs from readers.

Gesneriad Society International
P.O. Box 549
Knoxville, TN 37901
Has illustrated magazine, which is shared with the Saintpaulia International Society. Has photography section at most shows, slide fund, color slide programs.

The Orchid Digest Corporation
Orchid Digest Magazine
Jack Fowlie, M.D., Editor
1739 Foothill Boulevard
La Cañada, CA 91011
Illustrated magazine about orchids. Welcomes articles well supplied with top-quality photographs.

Cloudy-bright days are often excellent for landscapes where very dark foliage is combined with light subjects. Under the diffuse light, contrasts are not excessive, yet there is a full tonal range from stark white to black. Note how the photographer has chosen a low angle to emphasize the geometric layout of the garden. Design by Donald F. Pollitt, Inc.

Getting the Pictures You Want

When you are away from home, be sure to get the coverage you desire by taking enough different views. Taking only one photograph of a plant or garden is risky, first because it will only show one point of view, and second because negatives and slides are subject to damage. If one irreplaceable frame is scratched, you are without an important photograph; but if you have taken several views there will be at least one available, even after an accident.

Standard motion-picture or television techniques provide a useful format for garden and plant photography during your travels. Begin with a wide view or *long shot* showing general habitat. Next move in for a *medium view*, including your main subject. Finally, get close for detailed *close-ups* showing individual flowers, leaves, bark, or other significant features. When you photograph garden-related activities—such as planting, harvesting, processing—follow the same procedure: wide shott medium shot, close-ups.

Where the action is fast and steps cannot be repeated for your benefit, shoot fast. Vary your point of view and angles, too. Even professional documentary photographers seldom get more than two or three perfect frames out of ten taken. Once you are anywhere on location the least expensive thing is film; so take enough, and more, and shoot as many frames as necessary to get the photographs you want.

Around the Year

Some seasonal horticultural events, listed according to Northern Hemisphere orientation, are given here.

Spring

Azaleas: These begin in March in those states bordering the Gulf of Mexico; in mid-April in Baltimore, MD, and the famous mid-South gardens; into May for Northern states.

Easter conservatory displays are important at several botanical gardens, including New York Botanical Gardens and Longwood Gardens in Kennett Square, PA.

The festival honoring the Japanese flowering cherry trees of Washington, DC, is in April; the double-flowered variety blossom into late April.

Early spring brings almond blossom to Sicily, wildflowers to Greece.

Bulb fields in Holland (Keukenhof) come into glorious color from mid-April through May; the wholesale flower market at Aalsmeer (North Holland) is open mornings all year.

The world-famous Chelsea flower show is held in London in May.

Rose shows and garden displays are enjoyed in June at many locations.

Summer

All-America Selections display gardens are open to visitors.

Mid-July into September is excellent for gardens in Northern Hemisphere temperate regions, where annuals and perennials combine for colorful photographs.

Summer is also day lily (Hemerocallis) season. Spectacular tuberous begonias blossom in the commercial growing centers of Santa Cruz, CA.

Bedding plants are plentiful at Versailles in France and in many areas of Europe and North America.

Fall

Colorful fall foliage lights up Canada, the Northeastern and Rocky Mountain states, and temperate regions of Japan.

There is harvest activity in many places, and dahlia and chrysanthemum shows.

Camelias begin to bloom, continuing into winter, in California and the southern United States.

In the Southern Hemisphere, spring begins with wildflowers in South Africa, fruit trees in Chile and Argentina.

Winter

In cold regions, outdoor evergreens and tree branches create dramatic patterns on snow. Seed pods, tree bark, and hollies with berries are some attractive winter subjects in snowy places.

Everywhere gardeners and photographers visit conservatories to see holiday shows and commercial greenhouses to see the new houseplants.

Indoors, houseplants offer opportunities for portraits.

Late winter is a good time to visit semitropical Florida and California, where gardens remain active, also Central America, and the Caribbean region.

A "tapper" who has just made a fresh cut guides liquid latex—the sap of the rubber tree—down the bark to a collection cup at the base of the tree. Pictures like this show the economic value of trees and plants, for example as here in Malaysia.

9

Organizing
Your Photographs

Keeping track of your slides and prints will bring increased pleasure to garden photography. Being able to find favorite photographs when you need them is an easy matter when your collection is orderly. Begin by labeling plant portraits with genus, species, and perhaps clone names; cross-referencing may be useful. Most important of all is to protect the original negatives and slides from damage, dust, heat, and humidity.

Negatives

Store negatives in glassine or other envelopes specifically made for long-term negative storage. Most local camera stores stock suitable negative protectors.

Avoid touching the center of negatives or slides. Fingerprints are difficult to remove, attract dust, and will show on enlargements. Handle negatives by the edges, slides by the mounts. Scratches are even worse; so keep dust away and, when transporting or mailing negatives, put them, in their glassine envelopes, between stiff pieces of board. Do not

ship glass-mounted transparencies except in special packaging.

Number each roll of black-and-white or color negatives. If you are just starting a file system, begin with No. 1. Most popular 35 mm negative films have edge numbers for each frame. With this simple system, you have a roll number, then an individual *frame* number for each photograph on the roll. Some photographers group all the rolls exposed during a trip under a *series* number, as well.

Have *contact proof sheets* made from each roll when the film is processed. (Color negatives can be proofed in black and white to save money, if you wish.) The charge is reasonable; even top custom labs charge less than $5 to process 35 mm black-and-white film and provide a contact proof of the roll. File the contact proofs in three-

ring binders, with the newest roll at the front. Keep the negatives in a dark, dust-free drawer or special file cabinet where temperatures stay below 24 C (75 F) and humidity is less than 50 percent. High temperatures, humidity, and bright light are all harmful to both negatives and prints. For an in-depth discussion about storing photographs under less than ideal conditions, see pamphlet No. C-24, *Notes on Tropical Photography,* by the Eastman Kodak Company, Rochester, NY 14650.

Knowing names and places is important if you will be using your photos for lectures, identification, insurance, or publication. For negatives, type two copies of the *identification information.* One page can be taped to the back of its contact proof sheet. Use a tape that will not turn yellow or bleed adhesive, such as a good library tape or Scotch Magic Tape. Then when prints are made you have the caption details right there. Keep the copy of each information sheet in a permanent file or three-ring notebook. For more tips on finding the exact frame you want, see the later section headed *Keeping and Finding.* (The information can also be cross-referenced with your color work by means of a 3 × 5 card index.)

Communication with the lab

Clear communication with the person who enlarges the negatives will make sure ideas are realized in the final prints. Note basic requests for cropping, showing clearly what portion of each negative is to be enlarged, directly on the contact sheet with a "china marker" grease pencil. The standard professional markings will be understood by printers; so use them to convey your instructions.

Custom labs charge more than automated machine print places do because a trained printer must take time to evaluate each frame sent for enlargement. If your instructions are not realized, return the print with clear comments regarding a remake. Most labs will not charge for an occasional remake, provided your initial instructions were clear or the mistake was obviously theirs. If your negatives are scratched, dirty, incorrectly exposed, or otherwise substandard, however, the lab may even charge more to make an initial print.

If you feel the lab needs additional instructions, write them clearly. For example: "Series 60, Neg. #28, is light yellow flower—must have detail but should not be mushy gray. Please crop leaf at right, as shown on proof."

The contact proof is only a general guide to what each frame will look like. The lab technician who enlarges the negative can increase or decrease contrast, print some areas darker or lighter than seen on the proof, and crop, enlarge, or even eliminate parts of the original photo.

Standard cropping, variations in contrast, and making some areas lighter (*dodging*) or darker (*burning-in*) are included in the price of custom enlargements. Be sure to ask for *full-frame* prints if you want 100 percent of the frame shown, otherwise labs crop to fit standard paper sizes. This means cutting off material on the short sides, because the proportions of standard paper sizes are different from the proportions of 35 mm film.

More difficult work—eliminating backgrounds, removing parts of the photos such as a sign, pole, etc.—take more time and are charged for on an hourly basic. Badly scratched negatives make prints that require tedious spotting or retouching; so an extra charge is made for these, too.

With color negatives, the over-all tone or hue can be varied in printing. If you think a red amaryllis looks too blue or the sky too pink in your proof, request that enlargements be color-corrected. With a clear note listing what you want from each frame, a custom lab can use many of the same controls used in black-and-white printing: areas can be made darker or lighter, cropping done. If you often use color-negative film, consider including a color patch card in one frame of each roll, exposed under the same lighting conditions as the rest of the roll, or, in views that you intend to crop at the sides, include a color

patch in a corner that will not show on the final print. A standard color patch card is shown in the color section of this book.

Prints

From slides

Excellent color prints can be made directly from slides. There is a slight increase in contrast, so shadows have less detail. Well-exposed slides that do not need special manipulation can be machine-printed. For an extra charge, custom labs will dodge, burn-in, and spot (remove dust specks) on each color print.

If very big prints are required, with full control for color balance and manipulations, an *internegative* will be made for an additional fee. Save the internegative for future prints.

Show crop marks directly on slide mounts. Write out a brief note if you think more precise information is required; for example: "For slide #36, to be printed as an 8 × 10, please crop only at right, avoid cropping branch at left or top." If you have a small print that looks right for color balance, send it along as an example and mark any cropping on it with grease pencil.

Black-and-white enlargements

Prints *for publication* should be on semiglossy or glossy papers for best rendition of detail. *Display* prints often look nice with a luster or "silk" surface. There are fancy papers that resemble oil-painting "brush work", tapestry, or fabric. Your taste must dictate which surface is best for your purpose.

Prints that will be subjected to much handling should be made on doubleweight paper. These include all prints submitted to an agency or for publication. Smaller enlargements, like those for albums, and prints that will not often be handled, such as those intended for mounting or framing, can be printed on single-weight paper, which is slightly less costly.

Finishing

Color prints last longer when sprayed with a protective coating, especially if they are to be hung in open frames. Color labs offer matte, glossy, or semigloss sprays that will protect the print's surface.

A color print to be placed behind glass should be matted, or else mounted with a shim between it and the frame, so that there is a slight separation between print surface and glass. Keep prints out of direct sunlight for the longest lasting colors; the same is true for black-and-white prints, which can fade, too.

Special services

Many laboratories, including those of the film manufacturers, can make slides from color negatives. Some commercial labs will make black-and-white slides from black-and-white negatives; these are useful for slide shows. Large slides (6 × 6 cm from 2¼-format cameras or larger) can be duplicated in 35 mm size, and 35 mm slides can be enlarged to bigger slides.

Some labs will make prints from prints, but better quality is possible when you give the lab the original negative or slide. The makers of instant-print cameras, Polaroid and Kodak, will both make enlargements from their instant prints.

Keeping and Finding

Drawers with movable partitions for groups of slides are the most useful because new slides can be added without disrupting the whole file, which is not the case with boxes that have a slot for each slide. In garden photography it is usual to add slides of the same plant or garden every year or so.

Indexes

Keeping the groupings in the 35-mm slide boxes in which they are returned from the processor is satisfactory if you do not have to refer to the slides often. You can put a bold code number or write other information on the top, then put a number of them inside a covered storage carton or other dust-free place where temperatures and humidity are moderate.

Storing 35 mm slides in projector trays is practical for slide programs already edited and ready for projection, but will take too much space for large collections. If you do this, list each slide on a numbered index card (usually one comes with the slide tray) and put a copy in the file that holds your duplicate information sheets for your black-and-white shots.

Another way to index color slides is to spread all of them on a light box, then photograph them transluminated. Be sure to have enough light in the room to record the identification notes you have made on the mounts. Keep a master slide in the slide-show tray so you can later see all the slides together, just by projecting the group view. You can have this printed and file it with your black-and-white contacts, too.

Cross-references

Your system for finding slides should be tailored to the way you use photographs. This might involve a scientific genus and species file, arranged according to *plant types.* In my file, for instance, "Tropicals" and "Houseplants" are on one A-to-Z system, arranged by genus and species name; "Orchids" have their own drawers since they are a large category for me; "Outdoor Garden Plants" are divided into Annuals, Perennials, Wildflowers, Bulbs, Trees and Shrubs, each with the A-to-Z order according to genus and species.

Other slides can be grouped according to *theme,* then given a group number. For example, I have "Houseplant Culture" in group No. 133. Within this are several subgroups, each with a number, and individual slides have a letter code.

This system might work for you, too. Take an example, as follows:

Houseplant Pests. The main group is No. 133. The subgroup is No. 2 (Pests/Problems). A slide of mealybugs on coleus might thus be No. 133-C-2. Actually, there is no need to give each slide a letter code until such time as you must identify a specific frame, for instance when using the slide for publication or in a presentation. Until then, just a general number code (No. 133-2) will keep the slide from getting mixed in with the wrong category.

Since I refer to slides for lectures, symposium courses, and publication, the categories must be specific. When some close-ups occur in an overseas country file—let us say Sri Lanka—but I want to know about them in the regular A-to-Z houseplant file, I just put a small card in the slide drawer in place of the slide (to refer me to the Sri Lanka file) or else take the close-up from the Sri Lanka group of slides and leave a note on a slide-sized card that a close-up is in the A-to-Z houseplant drawer.

Gardens in various places can be given their own group number, then the group numbers cross-referenced in a card file. If you have many groups and lots of slides, make 3 × 5 cards for each category, with references to specific groups. For example, under a card labeled "Bromeliad Habitat" are several groups of tropical regions in Latin America. Another example could begin with one large category such as "Malaysia." On that card would be all the regions or habitats, by separate groups.

How detailed you make the file will depend on how *you* will use the slides.

Black-and-white work is also included on the 3 × 5 cards. One helpful reference is the date that most labs include on slide mounts. If you find a slide of a certain garden, say, but do not have a card reference about a

black-and-white series, you can look at the date on the slide, then check your black-and-white contacts from that month. Your file of copies of the shooting-data/caption-information can be helpful here, saving handling of the proof sheets.

Book notes

If you have a favorite garden book, especially of the encyclopedia or field-guide type, consider making marginal notes to your own slide groups or black-and-white rolls. One of my favorites is *Economic Botany,* a textbook about plants used for food, medicine, dye, lumber, fiber, and so on. Next to *Coffee* I have group numbers referring me to my files on Brazil, Colombia, Kenya. And my index cards for those areas note the significant book pages.

In Summary

The whole approach to a logical file system should be based on your own personal needs, but *some* sort of retrieval system—even the simplest of files, whether file folders, 3 × 5 cards, three-ring binders, or whatever—is a must for everyone who hopes to use and enjoy their photographs later.

Telling the Real Story

Your photographs will be more valuable if they are identified with subject information. Plant portraits are easy to label because you only need to list

the genus and species, plus perhaps the varietal name. Additional information may be useful to you, however, and it is certainly required if you wish to publish or display your photographs for a larger audience.

For example, the *date or season* of a photograph is often important. Even in the tropics the month in which a photo was taken makes a difference because seasons influence plant growth by variations in rainfall. In temperate climates, the difference to outdoor plants between cool, cold, and warm seasons is obvious. For houseplants, it is interesting to know whether they bloom in July or in January.

Horticultural notes are important for photos you will submit for publication. The speciality magazines are happy to receive clear, professional-looking photographs, but they must have solid material for captions: What potting mix did you use? Where was the plant grown? How often did you water it? Was any special technique used?

There is no need to write down what is obvious in the photograph, but if it is in black and white be sure to mention the color of the subject, as in tones of gray many colors look alike.

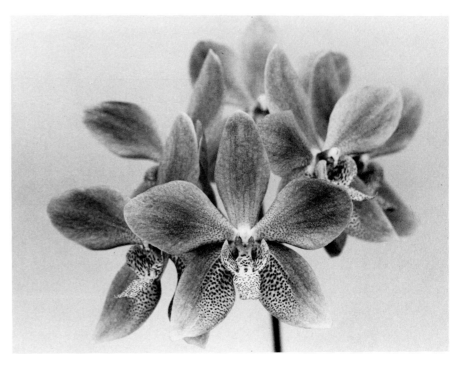

A 105 mm lens gives the viewer an intimate portrait of *Renanthopsis* Fiery Gem. There are many uses for such charming photographs.

Display and gift prints

For photos on display, prepare captions in large type (perhaps done by a printer or calligrapher or with rub-on letters) on cards that can be placed next to each enlargement.

Prints and slides sent to other people should have your name and address stamped on them. Cardboard slide mounts and fiber-base printing papers will accept standard rubber-stamp ink, but resin-coated printing papers and plastic slide mounts need special inks. There are now several pens that will write on RC paper without smearing or rubbing off. The alternative is to rubber-stamp self-stick labels and attach them to the resin-coated papers.

Captions

All photographs submitted for publication (and some of those put up for display) need captions. The words in a caption tell the viewer what is not obvious in a photograph. Often they provide background information and details that make the picture more valuable. Plant-society publications are often edited by volunteers who work hard and love plants but may have little or no training as editors. Your courtesy in supplying useful captions will be appreciated. If you hope to sell the photographs commercially, you will find that even if your work is useful for textbooks, horticultural magazines, or newspapers, it will only be acceptable if you have complete caption data available. The exception might be images made just to show the beauty or pattern of a subject; but

even here the photographs will interest a wider audience if basic information, such as genus, species, season, and location are given. Basic caption information for plant photographs includes

Genus and species (scientific) names

Variety or hybrid name, if known

Location and date (important for outdoor and overseas photos)

Details of plant culture (important for how-to photos, too)

Color notes (for black-and-white prints)

Grower's name (if important to the article or display)

and of course, most important for you,

Photographer's name and address (for correct credit line).

With 35 mm slides, only the most important data can be written on the limited space of each cardboard mount (about 50 × 13 mm, or just less than 2 in. across by ½ in. high) on the top edge of each slide mount. Use an ultra-fine-point pen to list subject name, your name, other *crucial* data only. Type additional facts on caption sheets to send along with slides submitted for publication, contests, or display.

Simple identification for black-and-white prints can be typed on self-stick labels, then fastened on the back of each print. (This is *not* the caption.)

In addition to this label with basic facts, including your name and code number, prepare a caption for each photograph. These captions should be typed on the *lower* half of a piece of paper, double spaced, and headed or signed with your name and your file code number. Fasten the paper to the back of the print with a piece of tape in such a way that the words hang below the picture. Fold it up over the face of the photograph when you prepare the delivery. You provide the separate caption sheet because photos for publication are often sent to a lab while the caption material goes to an editor. Easy-to-remove captions on the prints are therefore customary. When the caption is attached as described above, the recipient does not need to turn the picture over to read it.

For Further Reading

Abraham, George and Katy. *Organic Gardening Under Glass,* Emmaus, PA: Rodale Press, Inc., 1975.

An excellent guide to greenhouse gardening, describing how to design a greenhouse, start seeds, mix soils, control pests and diseases, and maintain the proper environment all year.

American Horticultural Society. *Directory of American Horticulture,* Mt. Vernon, VA: The American Horticultural Society.

This directory lists botanical gardens, plant societies, and display gardens. Very helpful in planning travels.

Bancroft, Keith. *Amphoto Guide to Lenses,* New York: Amphoto, 1981.

A basic introduction to photographic lenses, this book shows the effects that various types can produce. Special-purpose lenses, bellows, extension tubes, and other useful accessories are also described.

Birnbaum, Hubert C. *Amphoto Guide to Cameras,* New York: Amphoto, 1978.

Every type of still camera is shown and described in detail in this complete yet compact book, and suggestions are given about related equipment.

Carr, Anna. *Rodale's Color Handbook of Garden Insects,* Emmaus, PA: Rodale Press, Inc., 1979.

This full-color photographic guide identifies more than 200 pollinating, pestiferous, and predatory insects and tells about their ranges, life cycles, feeding habits, and host plants.

Fitch, Charles M. *The Complete Book of Houseplants,* New York: Dutton, 1972.

——. *The Complete Book of Miniature Roses,* New York: Dutton, 1972.

In these two books by the author of the volume you are reading, you will find practical, fully illustrated suggestions about growing ornamental plants.

Foster, Catherine O. *Orangic Flower Gardening,* Emmaus, PA: Rodale Press, Inc., 1975.

This complete flower-growing guide covers every step, from handling seeds and cuttings to the best ways to water, mulch, and transplant. It contains more than 45 color photographs and 50 line drawings.

——. *Plants-a-Plenty,* Emmaus, PA: Rodale Press, Inc., 1977.

The fascinating biological processes that play a part in plant multiplication are described in this heavily illustrated book. How and why seeds form and germinate; what conditions encourage root, leaf, and stem cuttings to send out shoots; what air layering is all about; grafting; and how to divide bulbs and tubers—these are a few of the topics included.

Halpin, Anne M. *Rodale's Encyclopedia of Indoor Gardening,* Emmaus, PA: Rodale Press, Inc., 1980.

The most complete plant book on the market, this volume provides exciting information for growing hundreds of ornamental and edible plants successfully in all kinds of indoor environments.

Holzman, Richard W. *Impact of Nature Photography,* New York: Amphoto, 1979.

This well-illustrated book concentrates on the aesthetics as well as the techniques of nature photography, especially of woodland plants.

Kinne, Russ. *The Complete Book of Nature Photography,* New York: Amphoto, revised edition 1979.

Methods, special equipment, and technical know-how are detailed in this authoritative work by a top professional nature photographer.

Kodak. *Encyclopedia of Practical Photography.* Rochester, NY: Eastman Kodak Company; New York: Amphoto; 1978.

This notable multivolume encyclopedia contains sections on landscapes, flowers, and close-ups, among other subjects helpful to the garden photographer.

——. *Photo Decor* (#0-22), Rochester, NY: Eastman Kodak Company, 1978.

Ways to use photographs as elements of design in interior decoration are described and illustrated in this "idea" book.

Lefkowitz, Lester. *The Manual of Close-up Photography,* New York: Amphoto, 1979.

This comprehensive modern reference treats all aspects of close-up photography, from inexpensive systems to special lenses to photocopying, slide duplication, and lighting (more than 270 extensively illustrated pages).

Thorpe, Don O. *Amphoto Guide to Available Light Photography,* New York: Amphoto, 1980.

If there is enough light to see, you can photograph. This book offers an introduction to advanced techniques for taking pictures in less than ideal light, as is often necessary when working in the field.

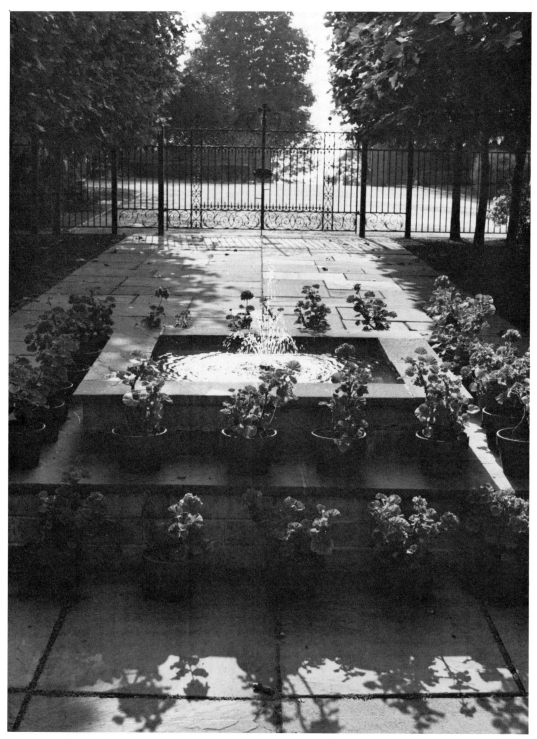

This picture has such a powerful sense of place you can almost walk into it. Many photographic elements combine to create this effect: lighting; composition; awareness of the relationships between plants and water, plants and trees; time of day—and of course the photographer's choice of camera position, lens, film, shutter speed, lens opening. The backlighted fountain, its drops blurred by motion, is at the exact center of converging shadows and lines. It is also the brightest thing in the picture, and the eye flies to it. The spray of water implies motion, but its position at the exact center is static; the result is a sense of repose, which is reinforced by long shadows characteristic of late afternoon, a restful time of day. This kind of picture is good for a wall display because it will be a long time before you have discovered all its possibilities. Photographed at Hammond Gardens, North Salem, New York.

Index